COOL
BERLIN

teNeues

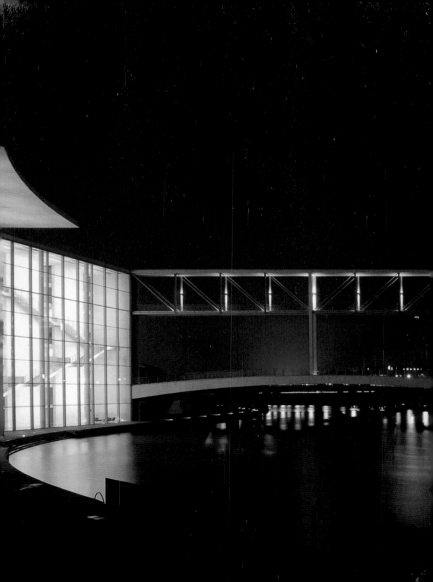

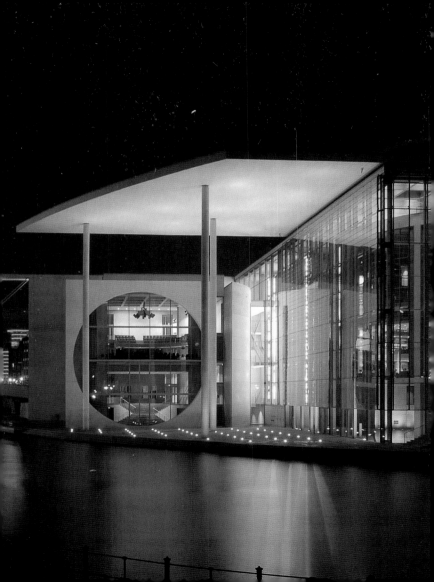

PRICE CATEGORY

$ = BUDGET $$ = AFFORDABLE $$$ = MODERATE $$$$ = LUXURY

COOL
CONTENT

INTRO

"POOR BUT SEXY"—WITH THIS
CASUAL STATEMENT, GOVERNING
MAYOR KLAUS WOWEREIT COINED
THE ULTIMATE BERLIN SLOGAN. IN JUST
THREE WORDS IT PERFECTLY SUMS UP
BERLIN'S ATTITUDE, ALLURE, AND
ITS PROBLEMS. IT'S ALSO A SNAPSHOT
OF BERLIN'S COOLNESS, WHICH IS
UNINTERRUPTED BUT CONSTANTLY
CHANGING. IF YOU HAVEN'T PAID A VISIT
TO BERLIN SINCE THE EARLY NINETIES,
YOU'RE IN FOR A SURPRISE, ESPECIALLY IF
YOU HEAD TO THE MITTE DISTRICT.
AFTER THE FALL OF THE BERLIN WALL,
RAUCOUS, ILLEGAL PARTIES SPRANG
UP IN THE MITTE DISTRICT; NOW,
THAT SAME AREA BOASTS NUMEROUS
FAMOUS GALLERIES AND FASHIONABLE
BOUTIQUES. WHILE BERLIN MAY
NOT BE VERY GLAMOROUS, IT IS A CITY
STEEPED IN HISTORY AT EVERY TURN
AND OFFERS AROUND THE CLOCK
EXCITEMENT. TUCKED AWAY HERE
AND THERE YOU'LL FIND OLD LEGENDS
AND ISLANDS OF GOOD TASTE,
AND WHILE THEY MIGHT NOT BE AS
OBVIOUS AS THE YOUNG GUNS,
THEY ARE COOL NONETHELESS.

„ARM, ABER SEXY" –
MIT DIESEM LÄSSIGEN AUSSPRUCH
PRÄGTE DER REGIERENDE BÜRGER-
MEISTER KLAUS WOWEREIT DEN BERLIN-
SLOGAN SCHLECHTHIN. IN NUR DREI
WÖRTERN FASST ER DAS LEBENSGEFÜHL,
DEN REIZ UND DIE PROBLEME BERLINS
PERFEKT ZUSAMMEN. NEBENBEI IST DAS
EIN SCHNAPPSCHUSS DER BERLINER
COOLNESS. DIE IST UNGEBROCHEN,
ABER IM STETIGEN WANDEL: WER
ZULETZT ANFANG DER NEUNZIGER DIE
SICH AUFBÄUMENDE STADT BESUCHTE,
WIRD SICH WUNDERN, BESONDERS
IN MITTE. WO MAN NACH DER WENDE
EXZESSIVE, ILLEGALE PARTYS FEIERTE,
REIHEN SICH HEUTE RENOMMIERTE
GALERIEN UND SCHICKE BOUTIQUEN
ANEINANDER. TROTZDEM IST BERLIN
NICHT GERADE GLAMOURÖS, WENN
AUCH ÜBERALL GESCHICHTSTRÄCHTIG
UND RUND UM DIE UHR VERGNÜGUNGS-
SÜCHTIG. DAZWISCHEN VERSTECKEN
SICH ALTE LEGENDEN UND INSELN DES
GUTEN GESCHMACKS. DIE OFFENBAREN
SICH NICHT SO WIE DIE JUNGEN WILDEN,
SIND ABER NICHT WENIGER „COOL".

INTRO

« PAUVRE MAIS SEXY », CES PAROLES LIBÉRÉES DU MAIRE DE BERLIN, KLAUS WOWEREIT, SONT DEVENUES LE SLOGAN BERLINOIS PAR EXCELLENCE. CES TROIS MOTS DÉCRIVENT PARFAITEMENT LA JOIE DE VIVRE, LE CHARME ET LES PROBLÈMES QUI RÈGNENT DANS LA CAPITALE BERLINOISE. C'EST ÉGALEMENT UN APERÇU DE LA NONCHALANCE BERLINOISE, QUI NE S'ÉTIOLE PAS AU FIL DU TEMPS, MAIS ÉVOLUE CONSTAMMENT. CEUX QUI ONT VISITÉ LA VILLE QUI A REJAILLI AU DÉBUT DES ANNÉES 90, SERONT ÉTONNÉS PAR SON ÉVOLUTION, PARTICULIÈREMENT DANS LE CENTRE DE LA CAPITALE. LÀ OÙ LES SOIRÉES ILLÉGA-LES BATTAIENT LEUR PLEIN À L'ÉPOQUE DE LA CHUTE DU MUR, ON TROUVE DÉ-SORMAIS DES GALERIES RENOMMÉES ET DES BOUTIQUES ÉLÉGANTES. POURTANT, BERLIN N'EST PAS VRAIMENT GLAMOUR, MÊME SI ELLE EST EMPREINTE D'HISTOIRE ET QU'ELLE EST LE THÉÂTRE DE TOUS LES AMUSEMENTS À TOUTE HEURE DU JOUR ET DE LA NUIT. ENTRE SES MURS SE CACHENT VIEILLES LÉGENDES ET BASTIONS DU BON GOÛT. ILS NE SONT PAS AUSSI VOYANTS QUE LA JEUNESSE ENDIABLÉE MAIS N'EN SONT PAS MOINS « COOL ».

"POBRE, PERO SEXY" –ESTA EXPRESIÓN
TAN ESPONTÁNEA FORMULADA POR
KLAUS WOWEREIT, ALCALDE DE BERLÍN,
PASARÍA A CONVERTIRSE EN SU ESLOGAN
POR ANTONOMASIA. TRES PALABRAS QUE
RESUMEN A LA PERFECCIÓN LA ACTITUD
VITAL, EL ENCANTO Y LOS PROBLEMAS
QUE ENVUELVEN LA CIUDAD Y QUE,
ADEMÁS, PROCURAN UNA INSTANTÁNEA
DE SU ESPÍRITU ENÉRGICO Y DESCARADO.
AQUELLOS QUE YA VISITARON ESTA
METRÓPOLI EMERGENTE A PRINCIPIOS DE
LOS 90 SE LLEVARÁN HOY UNA SORPRESA,
SOBRE TODO ANTE LA TRANSFORMACIÓN
DEL BARRIO MITTE. ALLÍ DONDE JUSTO
TRAS LA REUNIFICACIÓN DE ALEMANIA
SE CELEBRARON MULTITUD DE FIESTAS
ILÍCITAS Y EXCESIVAS, HOY SE CONGREGAN
GALERÍAS COMERCIALES Y BOUTIQUES DE
LO MÁS CHIC. Y AUNQUE NO SE DIRÍA QUE
BERLÍN ES UNA CIUDAD GLAMUROSA, SÍ
QUE ES UNA URBE REPLETA DE HISTORIA
E IRREFRENABLEMENTE DIVERTIDA A
CUALQUIER HORA DEL DÍA. EN ELLA,
LA ESTAMPA DE LA NUEVA GENERACIÓN
DISPUESTA A ROMPER MOLDES SALTA
A LA VISTA. LA CASI CLANDESTINA
PRESENCIA DE ANTIGUAS LEYENDAS
E ISLAS DEL BUEN GUSTO SUPONE UN
ALICIENTE MÁS.

HOTELS

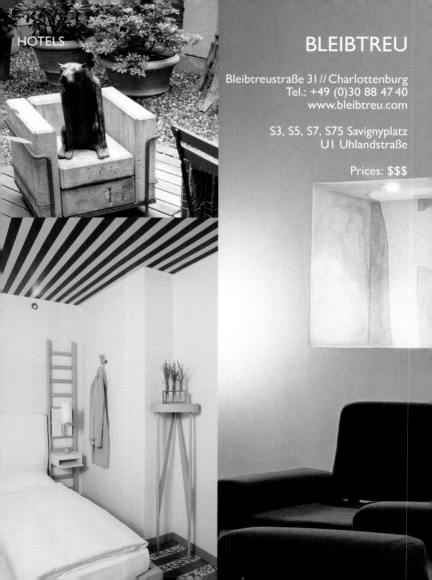

BLEIBTREU

Bleibtreustraße 31 // Charlottenburg
Tel.: +49 (0)30 88 47 40
www.bleibtreu.com

S3, S5, S7, S75 Savignyplatz
U1 Uhlandstraße

Prices: $$$

This friendly four-star hotel located between Ku'damm and Savignyplatz is an institution that offers much more than overnight accommodations in a perfect location. Plan to see and be seen while enjoying a delicious breakfast at Bleibtreu's Deli 31. Two of its 60 rooms are wheel-chair-accessible and all are allergy-friendly. The Bleibtreu Hotel embraces literature and the arts: it has set aside one room as a residence for international authors.

Das freundliche Vier-Sterne-Haus liegt zwischen Ku'damm und Savignyplatz und ist eine Institution. Denn man kann hier nicht nur in bester Lage übernachten. Auch für Externe lohnt sich ein Besuch im dazugehörigen Deli 31, für ein exzellentes Frühstück und zum Sehen und Gesehenwerden. Zwei der 60 Zimmer sind barrierefrei, alle sind allergikerfreund-lich. Das Bleibtreu ist auch ein Ort der Literatur: Ein Zimmer ist für internationale Autoren reserviert.

Cet accueillant hôtel quatre étoiles, situé entre le Ku'damm et la Savignyplatz, est une institution. Sa situation centrale et son restaurant Deli 31, qui attire des clients extérieurs venant y déguster un excellent petit-déjeuner, venant aussi pour voir et être vus, sont de sérieux atouts. Les 60 chambres de l'hôtel sont adaptées aux allergiques et deux d'entre elles peuvent recevoir des personnes à mobilité réduite. Le Bleibtreu est aussi un lieu de culture littéraire : une chambre est réservée aux écrivains internationaux.

Este acogedor hotel de cuatro estrellas, ubicado entre la Kurfürstendamm y la Savignyplatz, es toda una institución. El huésped se aloja en una de las mejores zonas de la ciudad y aquellos que sólo están de paso aprovechan para desayunar en el bar de delicatesen, para mirar y hacerse ver. Dos de las 60 habitaciones están acondicionadas para minusválidos. Todas son aptas para alérgicos. El hotel es también un enclave literario y posee una habitación reservada a los escritores internacionales.

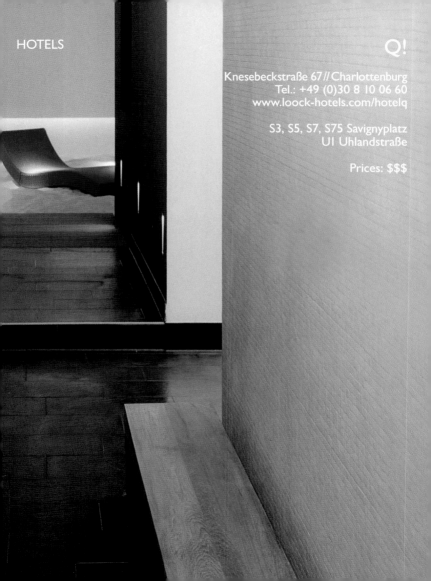

HOTELS

Q!

Knesebeckstraße 67 // Charlottenburg
Tel.: +49 (0)30 8 10 06 60
www.loock-hotels.com/hotelq

S3, S5, S7, S75 Savignyplatz
U1 Uhlandstraße

Prices: $$$

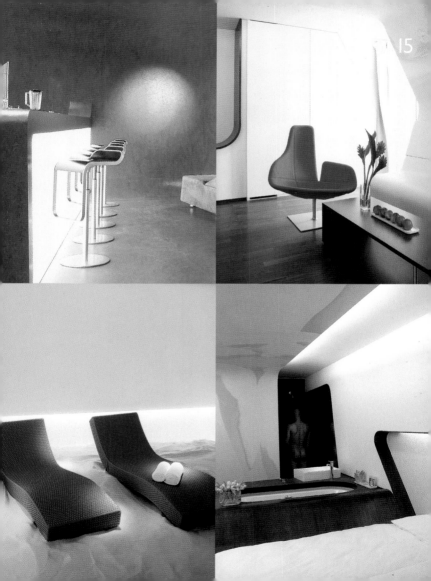

This award-winning hotel is one of the world's
best designer hotels. It was created by the GRAFT
collective, a firm that operates on the leading edge
of avant-garde architecture. One of their biggest
fans is Brad Pitt, who also appreciates Q!'s futuristic
luxury and rounded lines. He would doubtless enjoy
the bar with guaranteed privacy: it is reserved for
exclusive members. From the bathtub in bed to the
warm sand in the spa—Q! is damned sexy!

Das preisgekrönte Hotel gehört zu den besten
Designhotels weltweit. Geschaffen hat es das GRAFT-
Kollektiv, die Speerspitze der avantgardistischen
Architektur. Einer ihrer größten Fans ist Brad Pitt,
der auch den futuristischen Luxus ohne Ecken und
Kanten im Q! schätzt. Und vermutlich die Bar mit
garantierter Privatsphäre: Sie ist exklusiven Mitgliedern
vorbehalten. Von der Badewanne im Bett bis zum
warmen Sand im Spa – das Q! ist verdammt sexy.

Cet hôtel primé compte parmi les meilleurs hôtels
design du monde. Il a été créé par la collectivité GRAFT,
considérée comme le fer de lance de l'architecture
avant-gardiste. Un de ses plus grands fans n'est autre
que Brad Pitt, qui admire ce luxe futuriste tout en
rondeurs, et apprécie certainement le bar à l'intimité
assurée, exclusivement réservé aux membres.
Avec sa baignoire intégrée au lit et le sable chaud
de son spa, le Q! ne manque pas de sex-appeal !

El premiado hotel de diseño es de los mejores del
mundo. Ha sido creado por el estudio GRAFT, la punta
de lanza de la arquitectura de vanguardia. Uno de sus
mayores fans es Brad Pitt, el cual también aprecia el lujo
futurista de formas redondeadas del Q!. Seguramente
piense lo mismo del bar con garantía de privacidad:
está reservado a miembros exclusivos. Desde la
bañera intergada en la cama hasta la arena caliente
del spa —el Q! es condenadamente sexy.

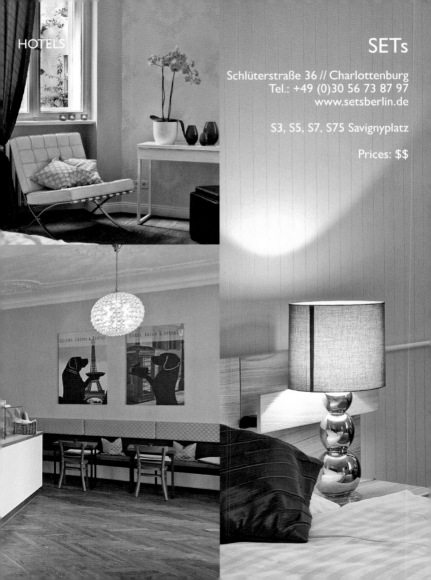

Sitting, eating, drinking, sleeping: owner Ruzica Krakan focuses on fulfilling her guests' every need and making their stay as pleasant as possible. You can enjoy the spacious café with its herringbone parquet floor while eating a hearty sandwich and chatting with someone at the next table. Don't want to leave? Not a problem, just book a room at SETs Bed & Breakfast.

Sitzen, essen, trinken, schlafen – grundlegende Bedürfnisse möglichst schön miteinander zu verknüpfen und es ihren Gästen dabei so angenehm wie möglich zu machen, darum geht es Ruzica Krakan. Ihr Caféraum ist großzügig angelegt, das Auge schweift über Fischgrätparkett und Stuck, während man eine zünftige Stulle verzehrt und sich mit dem Tischnachbarn in ein Gespräch vertieft. Wer hier nicht weg will, den laden Bed & Breakfast zum Verweilen ein.

Être assis, manger, boire, dormir – la préoccupation première de Ruzica Krakan est de satisfaire les besoins vitaux de sa clientèle en lui faisant passer de très bons moments. Vous réaliserez combien le café est généreusement aménagé lorsque vous laisserez planer votre regard sur le parquet en arêtes de poisson et les stucs, tout en dégustant un bon casse-croûte et en vous laissant aller à la conversation avec votre voisin de table. Ceux qui souhaitent rester peuvent séjourner au Bed & Breakfast.

Sentarse, comer, beber, dormir —¿cómo combinar y satisfacer estos elementos básicos de la felicidad de la mejor manera posible? Para conseguirlo, Ruzica Krakan, la propietaria de este establecimiento, invita a sus clientes a disfrutar de sabrosos bocadillos y charlas relajadas con los compañeros de mesa en el amplio café de suelos de parqué en espiga y techos estucados. Quien después ya no quiera abandonar este lugar puede hospedarse en la pensión propia del local.

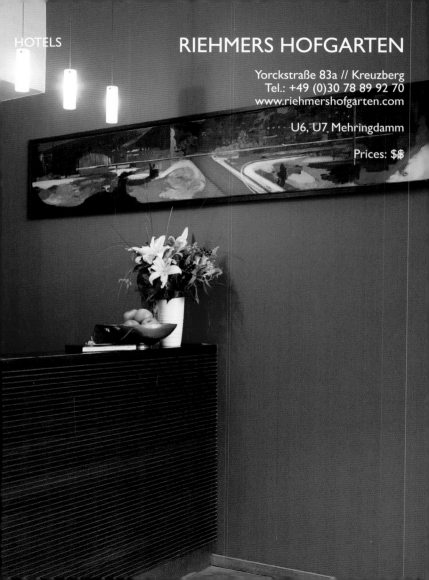

RIEHMERS HOFGARTEN

Yorckstraße 83a // Kreuzberg
Tel.: +49 (0)30 78 89 92 70
www.riehmershofgarten.com

U6, U7 Mehringdamm

Prices: $$

This historic and wonderfully preserved residential complex on Yorckstraße is unique in Berlin and all of Germany. Obstinate developer Wilhelm Riehmer spent four decades building the Wilhelminian complex with its landscaped courtyards. He died one year after it was finished in 1901. Today you will find a very charming hotel here with the excellent restaurant E. T. A. Hoffmann, as well as apartments for rental.

In Berlin und in ganz Deutschland einzigartig ist diese historische und wunderbar erhaltene Wohnanlage an der Yorckstraße. Der dickköpfige Baumeister Wilhelm Riehmer trieb den Bau des Gründerzeitkomplexes mit den begrünten Innenhöfen vier Jahrzehnte lang voran. Ein Jahr nach der Vollendung, im Jahre 1901, starb er. Heute befindet sich hier ein sehr sympathisches Hotel mit dem hervorragenden Restaurant E. T. A. Hoffmann und Appartements auf Zeit.

Ce complexe d'habitations historique et bien entretenu de la Yorckstraße est considéré comme un lieu unique à Berlin et dans toute l'Allemagne. Pendant quatre décennies, Wilhelm Riehmer, un ingénieur têtu, a mené les travaux de construction de ce complexe avec espaces verts datant du Gründerzeit (époque des fondateurs). Il s'est éteint en 1901, un an après son achèvement. On y trouve désormais un hôtel agréable et l'excellent restaurant E. T. A. Hoffmann ainsi que des appartements à louer.

Esta histórica y estupendamente conservada urbanización en la Yorckstraße es única en Berlín y en toda Alemania. El testarudo jefe de obra Wilhelm Riehmer impulsó durante cuatro décadas la construcción del complejo de la época Gründerzeit con sus patios ajardinados. Murió en 1901, un año después de la terminación del proyecto. Hoy se encuentran aquí un hotel muy simpático con el fantástico restaurante E. T. A. Hoffmann y apartamentos de alquiler.

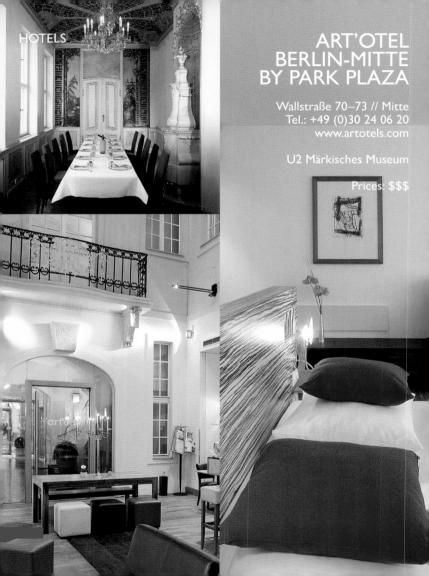

ART'OTEL
BERLIN-MITTE
BY PARK PLAZA

Wallstraße 70–73 // Mitte
Tel.: +49 (0)30 24 06 20
www.artotels.com

U2 Märkisches Museum

Prices: $$$

The name is the concept: each hotel is dedicated to
an artist, and in Berlin Mitte it's the great Georg Baselitz.
Original works of art by Baselitz are displayed throughout
the hotel, which means you can enjoy his artwork
during your stay—kind of like being locked in a gallery
overnight, but much more comfortable. The hotel's outer
façade conceals a spacious restaurant and a bar in the
glass-roofed atrium.

Der Name ist Konzept: Jedes Hotel ist einem Künstler
gewidmet, in Mitte ist es der große Georg Baselitz.
Dessen Originale hat man während des ganzen Aufenthalts
vor Augen, was eine intensive Auseinandersetzung mit
der Kunst ermöglicht – ungefähr so, als ob man sich
über Nacht in einer Galerie einschließen lässt, nur viel
komfortabler. Hinter der schlichten Außenfassade
versteckt sich ein großzügiges Restaurant und eine Bar
im Atrium mit Glasdach.

Son nom est déjà un concept à lui seul : chaque hôtel
est dédié à un artiste différent. Celui de Georg Baselitz
est situé au centre de la capitale. Le voyageur baigne
dans l'univers du peintre, où sont exposées les œuvres
originales de ce dernier. On a l'impression de passer la
nuit dans une galerie d'art, mais plus confortablement.
Passé la façade à l'architecture sobre, on découvre un
grand restaurant et un bar dans l'atrium surplombé
d'un toit de verre.

El nombre refleja el concepto detrás esta cadena.
Cada hotel está consagrado a un artista distinto. En
el del barrio Mitte todo gira alrededor del gran Georg
Baselitz. Sus cuadros adornan las habitaciones y salas,
acercando el arte al ojo del huésped. Es como pasar
una noche en una galería de arte, sólo que muchísimo
más cómodo. Detrás de la sencilla fachada se esconde
un amplio restaurante y el atrio con techo de cristal
que alberga el bar.

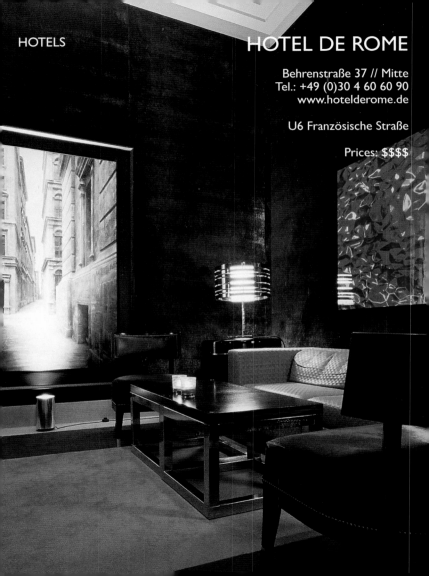

HOTELS

HOTEL DE ROME

Behrenstraße 37 // Mitte
Tel.: +49 (0)30 4 60 60 90
www.hotelderome.de

U6 Französische Straße

Prices: $$$$

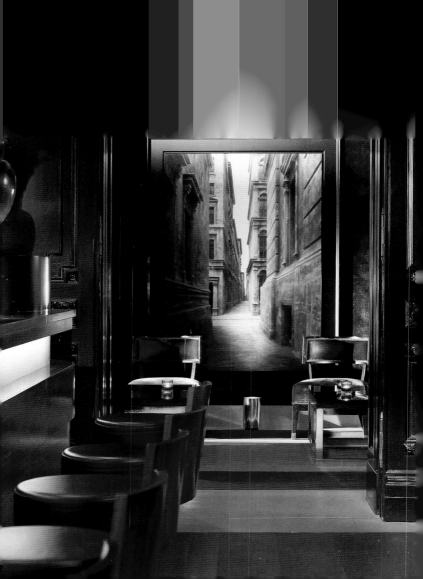

Once a jewel vault, these days you can enjoy swimming in its lap pool, and the wood paneling of the executive suites still harbors a few shell splinters—traces of World War II intentionally left in place. Sir Rocco Forte and his team have preserved the history of the building and fused it with ultra-modern conveniences. The hotel on Bebelplatz, built at the end of the 19th century and used as a bank until 1945, is one of the city's most prestigious addresses.

Im alten Juwelenraum kann man heute stilvoll Bahnen schwimmen, in den Holzverkleidungen der Executive Suites stecken zum Teil noch Granatsplitter – bewusst belassene Spuren des Zweiten Weltkriegs. Sir Rocco Forte und sein Team haben die Geschichte des Hauses bewahrt und mit modernstem Komfort verbunden. Das Hotel am Bebelplatz, im ausgehenden 19. Jahrhundert erbaut und bis 1945 als Bank genutzt, ist eine der vornehmsten Adressen der Stadt.

Cet hôtel de luxe porte encore les traces de la seconde guerre mondiale : l'ancienne salle des bijoux a été réaménagée en piscine intérieure de luxe et les parois en bois des « suites Exécutive » comportent encore des éclats d'obus. Sir Rocco Forte et son équipe ont préservé l'histoire de cet établissement en y apportant une touche de confort moderne. Cet hôtel de la Bebelplatz, construit au fin de 19e siècle et ayant abrité une banque jusqu'en 1945, est l'une des adresses les plus distinguées de la ville.

En la antigua sala de joyas uno puede darse hoy un chapuzón con estilo. En las paredes revestidas de madera de algunas de las suites aún hay casquillos de granada —vestigios de la II Guerra Mundial intencionalmente conservados. Sir Rocco Forte y su equipo han preservado la historia de la casa y la han dotado del confort más moderno. El edificio en la Bebelplatz fue construido a finales del siglo XIX y acogió un banco hasta 1945. Sigue siendo uno de los lugares más selectos de la ciudad.

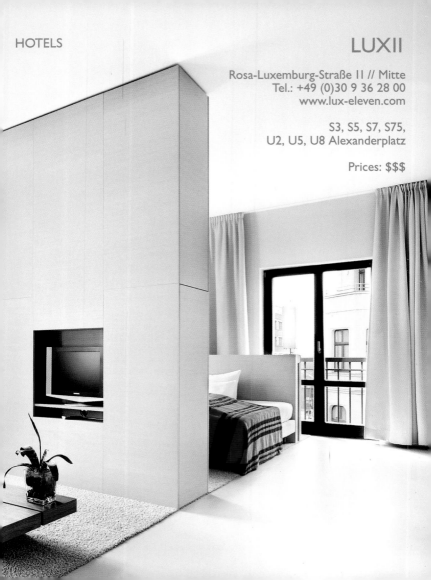

LUXII

Rosa-Luxemburg-Straße 11 // Mitte
Tel.: +49 (0)30 9 36 28 00
www.lux-eleven.com

S3, S5, S7, S75,
U2, U5, U8 Alexanderplatz

Prices: $$$

Instead of a chocolate on your pillow, you'll find
a Spreewald pickle as a goodnight treat at Lux 11.
This combination of humor and individuality links this
hotel to its big brother, The Weinmeister. International
travelers can relax in one of the 72 open-plan guest
suites, then stop by the lobby for a midnight snack
before heading out to sample the Berlin nightlife.
It's hard to believe that the KGB once resided in this
lovely Wilhelminian building.

Statt Schokolade liegt im Lux 11 ein regionales Spree-
waldgürkchen als Betthupferl auf dem Kopfkissen. Diese
Mischung aus Humor und Individualität verbindet das
Haus mit seinem großen Bruder, dem The Weinmeister.
„Globale Nomaden" können in einer der 72 offen
und klar gestalteten Suiten zur Ruhe kommen. Oder
den Mitternachtssnack in der Lobby einnehmen und
in die Berliner Nacht entschwinden. In dem schönen
Gründerzeithaus residierte einst der KGB.

Au Lux 11, la friandise posée sur l'oreiller n'est pas
un chocolat, mais bien un cornichon « Spreewald » de
la région. Ce mélange d'humour et de personnalisation
rappelle l'ambiance de son grand frère, The Weinmeister.
Les « nomades du monde entier » trouveront le repos
dans l'une des 72 suites aménagées et pourront savourer
une collation de minuit dans le lobby, avant de disparaître
dans la nuit berlinoise. Cet établissement datant du
Gründerzeit a autrefois abrité le KGB.

En lugar de la chocolatina de buenas noches, en el
Lux 11 se colocan sobre la almohada pepinillos regionales
del Spreewald. Esta mezcla de humor e individualidad
une a esta casa con su hermamo mayor, el The Wein-
meister. Los "nómadas globales" pueden descansar en
alguna de las 72 suites decoradas de forma espaciosa y
clara. O tomar el aperitivo de medianoche en el lobby
y perderse en la noche berlinesa. En la bonita casa de
la época Gründerzeit residió antiguamente el KGB.

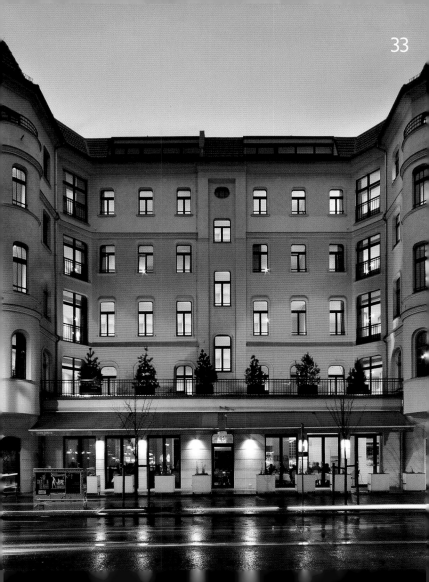

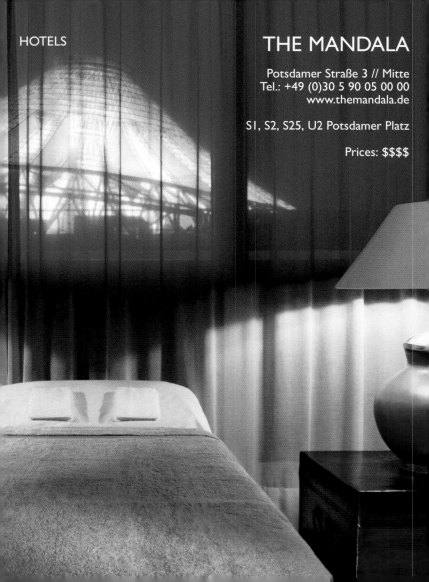

HOTELS

THE MANDALA

Potsdamer Straße 3 // Mitte
Tel.: +49 (0)30 5 90 05 00 00
www.themandala.de

S1, S2, S25, U2 Potsdamer Platz

Prices: $$$$

There are not many privately run top-class hotels these days. That in itself separates the Mandala at Potsdamer Platz from the masses. Its focus is on the well-being of the guests. They are given enormous suites with high-tech kitchens and daybeds—including skyline view. This can also be enjoyed at the ONO Spa, a true temple of calm and wellness. After relaxation comes pleasure in the star-winning restaurant Facil.

Heutzutage gibt es wenige privat geführte Hotels der Spitzenklasse. Das Mandala am Potsdamer Platz hebt sich allein schon dadurch von der Masse ab. Sein Fokus liegt auf dem Wohl der Gäste. Ihnen stehen riesige Suiten mit Hightech-Küche und Tagesbett zur Verfügung – inklusive Blick auf die Skyline. Den genießt man auch im ONO Spa, einem wahren Ruhe- und Wellnesstempel. Im gläsernen Sterne-Restaurant Facil folgt auf die Entspannung der Genuss.

Les hôtels privés de première classe sont rares de nos jours. Le Mandala de la Potsdamer Platz se distingue nettement. La politique de l'hôtel est axée sur le bien-être de sa clientèle. De grandes suites aménagées équipées de cuisines high-tech et divans-lits douillets avec vue sur la skyline s'offrent à ses clients. Ils peuvent également profiter du calme dans le centre de bien-être ONO Spa. À la détente succède le plaisir culinaire dans le restaurant étoilé Facil entouré de parois de verre.

Hoy en día quedan pocos hoteles de primera clase en manos privadas. Sólo por eso, el Mandala en la Potsdamer Platz sobresale por encima del resto. Se centra en el bienestar de los huéspedes. A su disposición se encuentran enormes suites con cocina de alta tecnología y sofás cama —vistas al panorama urbano incluidas. Esto también se disfruta en el spa ONO, un verdadero templo de la tranquilidad y la salud. En el restaurante con estrella acristalado Facil, el relax da paso al placer.

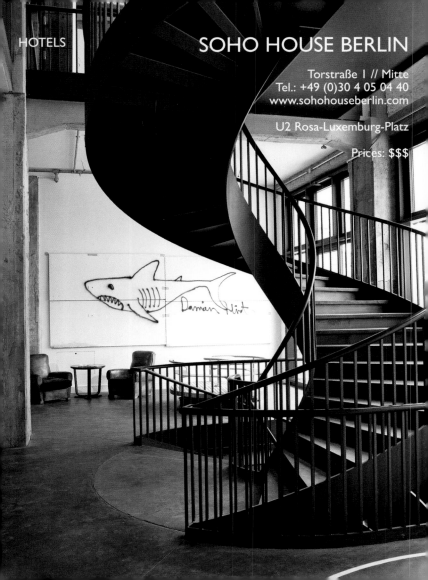

SOHO HOUSE BERLIN

Torstraße 1 // Mitte
Tel.: +49 (0)30 4 05 04 40
www.sohohouseberlin.com

U2 Rosa-Luxemburg-Platz

Prices: $$$

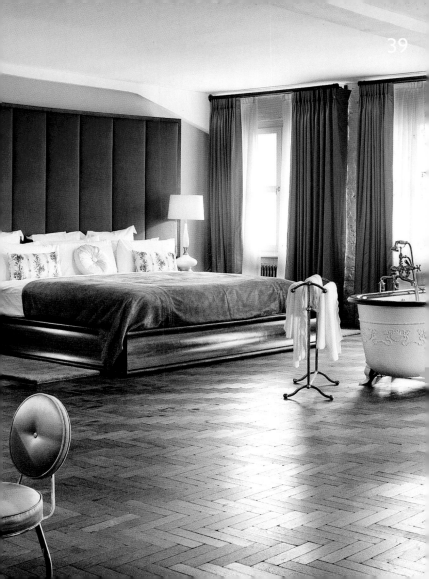

Named for its "parent house" in London's Soho district, the private club established itself in Berlin in 2010. Over the course of history the landmark-protected building housed a Jewish department store, the headquarters of the Hitler Youth, and the Politburo of the East German Communist Party. It's looking fairly glamorous here these days. The roof deck is spectacular with its pool and bar. Nonmembers can also spend the night in the club's 40 comfortable rooms.

Der Privatclub, benannt nach dem „Mutterhaus" im Londoner Stadtteil Soho, hat sich 2010 auch in Berlin niedergelassen. In dem denkmalgeschützten Gebäude war im Lauf der Geschichte unter anderem ein jüdisches Kaufhaus, die Zentrale der Hitlerjugend und das Politbüro der SED untergebracht. Heute ist es hier ziemlich glamourös. Spektakulär ist die Dachterrasse mit Pool und Bar. In den 40 gemütlichen Zimmern können auch Nichtmitglieder übernachten.

TITA VON HARDENBERG'S SPECIAL TIP

If you can still get a room here, don't wait another minute. Once you've checked in, there's no reason to leave.

Ce club privé portant le nom de la « maison-mère » du quartier londonien de Soho a ouvert ses portes en 2010 à Berlin. Ce monument classé historique a autrefois abrité consécutivement un grand magasin juif, la centrale de la jeunesse hitlérienne et les bureaux du parti politique SED. L'endroit est devenu plutôt glamour de nos jours. Le toit-terrasse avec piscine et bar est un lieu spectaculaire. Les non-membres peuvent également passer la nuit dans le confort d'une des 40 chambres.

El club privado, cuyo nombre proviene de la "casa madre" en el barrio londinense del Soho, se estableció en Berlín en 2010. El edificio, monumento histórico protegido, albergó a lo largo de la historia un centro comercial judío, la central de las Juventudes Hitlerianas y el Politburó del PSUA. Hoy es bastante glamoroso. La terraza de la azotea con piscina y bar es espectacular. En las 40 cómodas habitaciones también pueden dormir personas que no sean miembros.

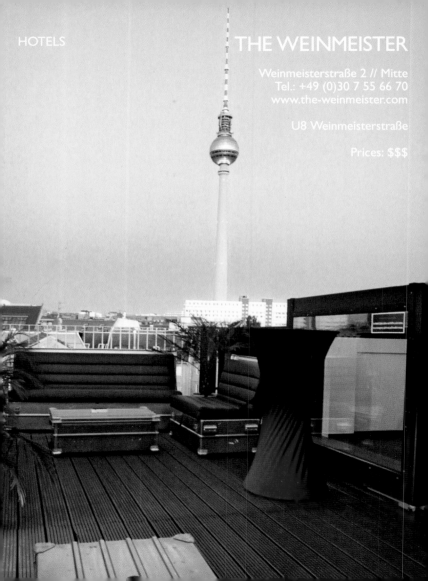

THE WEINMEISTER

Weinmeisterstraße 2 // Mitte
Tel.: +49 (0)30 7 55 66 70
www.the-weinmeister.com

U8 Weinmeisterstraße

Prices: $$$

At The Weinmeister, oversized six-by-six feet beds dominate the rooms and emphasize comfort. Beyond its luxury and outstanding design, this hotel on Rosenthaler Platz truly focuses on personal touches. The Weinmeister attracts a youthful, creative clientele and treats them like treasured friends, not guests. Named after actress Jessica Schwarz, the bar serves an herbal schnapps made using the secret Schwarz family recipe.

Das Bett misst im The Weinmeister zwei mal zwei Meter und steht in seiner gemütlichen Überdimensionalität im Mittelpunkt von allem. Das ist sehr sympathisch. Neben allem Luxus und vorbildlichem Design geht es im Hotel am Rosenthaler Platz um die persönliche Note. Die zumeist jungen Menschen aus der Kreativszene sind eher geschätzte Freunde, weniger Gäste. In der nach der Schauspielerin Jessica Schwarz benannten Bar bekommen sie einen Kräuterschnaps nach Schwarz'schem Familienrezept.

Au The Weinmeister, les lits surdimensionnés (deux per deux mètres) règnent en maître. Dans cet hôtel sympathique de la Rosenthaler Platz, où luxe et design sont rois, l'accent est mis sur les petites touches personnelles. La plupart des jeunes artistes qu'on y rencontre sont plus des amis que des clients. Dans le bar portant le nom de l'actrice Jessica Schwarz, vous dégusterez une liqueur aux herbes préparée d'après une recette de la famille Schwarz.

En este hotel las camas miden dos metros por dos y, con su colosal comodidad, se convierten en las protagonistas del espacio; cosa que resulta chocante. Aparte de por el lujo y el diseño, el hotel en la Rosenthaler Platz apuesta por un trato muy personalizado. Los huéspedes, en su mayoría jóvenes del mundillo creativo, son tratados más como amigos que como clientes. En su bar, que porta el nombre de la actriz Jessica Schwarz, se les ofrece un licor de hierbas de receta de la estirpe Schwarz.

MENSCHLICHER WILLE KANN ALLES VERSE

DIESES HAUS STAND
FRÜHER IN EINEM
NDEREN LAND

RESTAURANTS
+CAFÉS

RESTAURANTS
+CAFÉS

JULES VERNE

Schlüterstraße 61 // Charlottenburg
Tel.: +49 (0)30 31 80 94 10
www.jules-verne-berlin.de

Daily 9 am to 1 am

S3, S5, S7, S75 Savignyplatz

Prices: $$
Cuisine: French

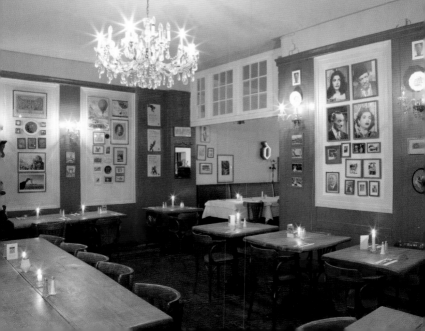

To get here, skip the balloon and submarine and take the S-Bahn to Savignyplatz instead. The breakfast menu lists tempting dishes such as "Two Years' Vacation" and "Twenty Thousand Leagues Under the Sea." Whether you read the paper in the mornings, meet colleagues for lunch, or swing by with friends for dinner, it's always affordable and worth a trip. The front room has the attractive simplicity of a bistro, while the red room in the back is lively.

In dem Fall verzichtet der Reisende besser auf Ballon und U-Boot und fährt mit der S-Bahn. Das Ziel liegt an der Station Savignyplatz und lockt morgens z. B. mit „Zwei Jahre Ferien" und „20.000 Meilen unter dem Meer". Die Reise lohnt sich immer, und sie ist erschwinglich. Ob nun in der Früh mit Tageszeitung, mittags mit Kollegen oder abends mit Freunden. Der vordere Raum hat die schöne Schlichtheit eines Bistros, hinten ist es rot und lebendig.

Le voyageur renoncera à faire le voyage en ballon ou sous-marin, il prendra plutôt le RER. Son itinéraire se terminera à la station Savignyplatz, où il pourra se replonger dans « Deux ans de vacances » et « Vingt-mille lieues sous les mers ». Pour y lire le journal au petit matin, déjeuner avec des collègues ou dîner avec des amis, le voyage vaut le détour et est à la portée de tous. De la première salle du restaurant émane la simplicité d'un bistrot. Dans l'arrière-salle aux murs rouges, l'ambiance est plus vive.

Para llegar aquí, mejor coger el tranvía y olvidarse del globo y del submarino. El destino se encuentra en la parada de Savignyplatz y atrae con ofertas que invitan a pasar "Dos años de vacaciones" o a realizar "Veinte mil leguas de viaje submarino". La excursión siempre vale la pena —ya sea para desayunar con el periódico, comer con los compañeros de trabajo o cenar con amigos— y es económica. La entrada está decorada de manera sencilla, y en la parte trasera, más animada, predomina el color rojo.

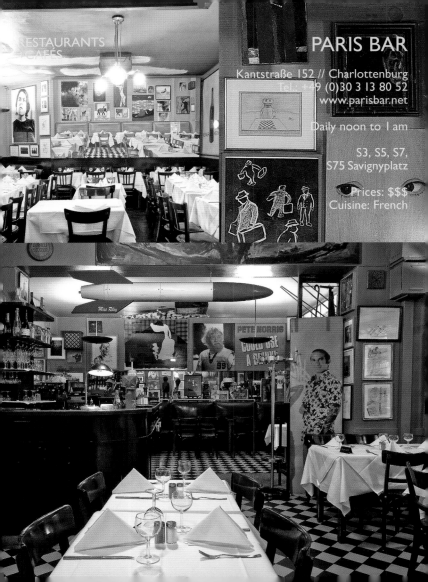

RESTAURANTS
& CAFÉS

PARIS BAR

Kantstraße 152 // Charlottenburg
Tel.: +49 (0)30 3 13 80 52
www.parisbar.net

Daily noon to 1 am

S3, S5, S7,
S75 Savignyplatz

Prices: $$$
Cuisine: French

"Anyone who enters here should give up any hope of coming out before morning. Or of coming out the same as he went in." So wrote playwright Heiner Müller in describing the allure of the West German legend on Kantstraße. The bar—actually an Austrian-run restaurant serving French fare—has a resolute character. For that and for its authentic patina it has been loved by director Rainer Werner Fassbinder, among others.

„Wer hier eintritt, lasse alle Hoffnungen fahren, dass er herauskommt, ehe es Morgen wird. Und dass er herauskommt als der gleiche, der hineinging." So hat Heiner Müller die Faszination der westberliner Legende in der Kantstraße in Worte gefasst. Die Bar, eigentlich ein österreichisch geführtes Restaurant mit französischer Küche, hat einen unbeugsamen Charakter. Dafür und für ihre echte Patina liebte sie einst auch Rainer Werner Fassbinder.

TITA VON HARDENBERG'S
SPECIAL TIP

Still the best place in the West and a legend. Anyone still sitting here after midnight will inevitably make new friends.

« Toi qui entre ici, abandonne toute espérance de rentrer avant le lever du jour ! Et d'être le même homme en sortant ! » C'est ainsi que le dramaturge Heiner Müller témoigna de sa fascination pour la légende ouest-allemande de la Kantstraße. Ce bar, ou plutôt ce restaurant dirigé par un Autrichien proposant une cuisine française, affiche un caractère bien trempé. C'est ce qui, en plus de sa véritable patine, séduisit le réalisateur Rainer Werner Fassbinder.

"Aquel que entre aquí renuncia a toda esperanza de volver a salir antes de que amanezca; e incluso a salir siendo la misma persona que entró." El dramaturgo Heiner Müller describió por entonces la fascinación por la leyenda de Alemania del Oeste ubicada en la Kantstraße. El bar —en realidad un restaurante austríaco que ofrece cocina francesa— ostenta un carácter único y un carisma que ha cautivado ya a clientes tan ilustres como el director de cine Rainer Werner Fassbinder.

SCHNEEWEISS

Simplonstraße 16 // Friedrichshain
Tel.: +49 (0)30 29 04 97 04
www.schneeweiss-berlin.de

Mon–Fri 6 pm to 1 am
Sat–Sun 10 am to 1 am

S3, S5, S7, S9, S75, U1 Warschauer Straße
U5 Frankfurter Tor

Prices: $$$
Cuisine: German

Seek out this bright oasis in the middle of dingy
Friedrichshain if you feel in need of a smart and
tasteful antidote to Berlin's sensory overload.
Opened in 2004 by Denis Ranogajec and Ralf Kern,
this restaurant won the IF Design Award for its
snow-white interior and is famous for its traditional
alpine cuisine and cosmopolitan clientele. Guests
are welcome to smoke in the fireside lounge.

Mitten im schmuddeligen Friedrichshain liegt diese
helle Oase, die der Berliner Reizüberflutung auf
sehr schicke und schmackhafte Art Einhalt gebietet.
Das von Denis Ranogajec und Ralf Kern 2004 eröffnete
Restaurant hat für seine schneeweiße Inneneinrichtung
den IF Design Award erhalten und ist darüber hinaus
berühmt für seine zünftige Alpenküche und seine
illustre, gemischte Kundschaft. Raucher dürfen es
sich im Kaminzimmer gemütlich machen.

Cette oasis d'un blanc immaculé, située dans le
quartier à la propreté douteuse de Friedrichshain,
réfrène avec style et goût le trop-plein de sollicitations
de Berlin. Ce restaurant de Denis Ranogajec et
Ralf Kern a ouvert ses portes en 2004 et remporté
le prix IF Design pour son décor blanc comme neige.
Sa cuisine typique des Alpes est renommée, tout
comme sa clientèle cosmopolite. Le coin cheminée
est réservé aux fumeurs.

Este oasis se encuentra en medio del descuidado
barrio Friedrichshain, poniendo coto de forma muy
elegante y sabrosa al exceso de estímulos berlinés.
El restaurante abierto por Denis Ranogajec y Ralf Kern
en 2004 consiguió el Premio de Diseño IF por su
decoración blanca como la nieve y es, además, famoso
por su cocina alpina auténtica y su ilustre y variada
clientela. Los fumadores pueden ponerse cómodos
en la habitación de la chimenea.

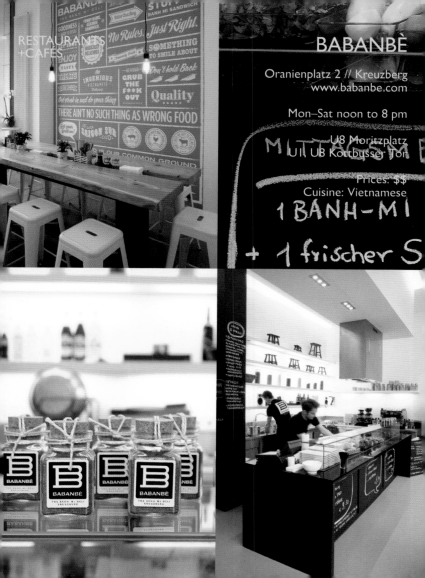

BABANBÈ

Oranienplatz 2 // Kreuzberg
www.babanbe.com

Mon–Sat noon to 8 pm

U8 Moritzplatz
U1 U8 Kottbusser Tor

Prices: $$
Cuisine: Vietnamese

Don't underestimate the risk of becoming addicted to bành mí. The Franco-Vietnamese sandwiches put everything else in the "bread with fillings or toppings" category to shame. The other dishes, too, are prepared with visible care and enthusiasm by the three friends (babanbè in Vietnamese). Inspired by their travels, they transplanted Ho Chi Minh City street fare to Kreuzberg and have been creating happy addicts here since the autumn of 2010.

Man darf die Suchtgefahr der Bành Mí nicht unterschätzen. Die franko-vietnamesischen Sandwiches stellen alles, was sonst unter „belegtem Brötchen" firmiert, in den Schatten. Auch die anderen Gerichte bereiten die drei Freunde (vietnamesisch: Babanbè) mit sichtlicher Sorgfalt und Begeisterung zu. Vom Reisen inspiriert, verpflanzten sie die Straßenküche von Ho-Chi-Minh-Stadt nach Kreuzberg und machen hier seit Herbst 2010 glücklich abhängig.

Le risque de devenir accro au bành mí est à prendre très au sérieux. Les sandwichs franco-vietnamiens dépassent de loin ce que l'on entend par « petits pains garnis ». Les autres plats sont également préparés avec soin et enthousiasme par les trois amis (babanbè, en vietnamien). Inspirés par leurs voyages, ces trois amis ont ramené en 2010 la cuisine de rue de Hô-Chi-Minh-Ville à Kreuzberg et font la joie de leur clientèle devenue addict.

No hay que subestimar el carácter altamente adictivo de los bành mí. Estos bocadillos franco-vietnamitas eclipsan todo aquello que se pueda calificar de "bocata". También el resto de platos son elaborados por los tres amigos (en vietnamita, babanbè) con gran mimo y dedicación. Inspirado en sus viajes, el grupo de amigos importó la cocina callejera de Ciudad Ho Chi Minh al barrio de Kreuzberg, donde, desde otoño de 2010, ha conseguido crear una feliz adicción entre el público.

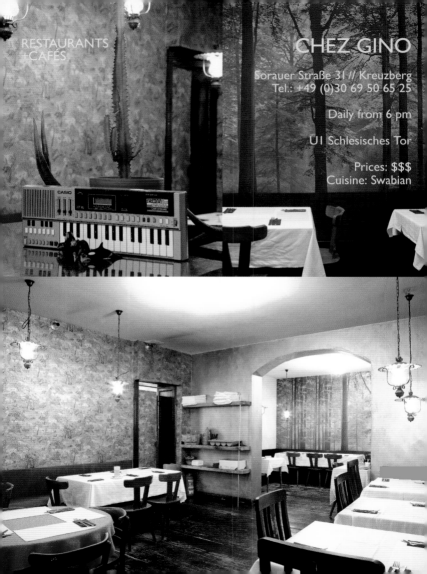

CHEZ GINO

Sorauer Straße 31 // Kreuzberg
Tel.: +49 (0)30 69 50 65 25

Daily from 6 pm

U1 Schlesisches Tor

Prices: $$$
Cuisine: Swabian

One time when Volker was in Auckland, he over-heard someone raving about a place in Berlin "named something like Ginos" that served "the best tarte flambée in the world," and he realized they were talking about his own restaurant! With its delicacies and unpretentious décor, regulars have been trying to keep the place a secret for years. They don't like the thought of having to share the blood sausage, stew, and fruit brandy.

Als Volker mal in Auckland war, schwärmte jemand von Berlin und „dem besten Flammkuchen der Welt", den es dort gäbe, „bei Gino, oder so". Es stellte sich heraus, dass sein eigener Laden gemeint war. Seit Jahren versuchen die Stammgäste, das Lokal mit den ausgesuchten Leckereien und der unprätentiösen Einrichtung geheim zu halten. Sie teilen die Boudin Noir (Blutwurst), das Geschmorte und den Obstler einfach ungern.

Lors d'un voyage à Auckland, Volker rencontra quelqu'un qui lui parla avec enthousiasme de Berlin et de « la meilleure tarte flambée du monde » que l'on trouve « Chez Gino, ou un nom dans ce genre ». Il réalisa que l'inconnu parlait de son propre restaurant. Depuis des années, les habitués tentent de garder secret cet établissement sans prétention avec ses mets exquis, ne voulant tout simplement pas partager le boudin noir, les plats mijotés ni les eaux-de-vie.

Un día, Volker visitó la ciudad de Auckland y allí escuchó a alguien hablar de las "mejores tartas flambeadas" de Berlín servidas en un sitio llamado "donde Gino o algo así". Resulta que se estaba refiriendo al local del mismo Koenitz. Desde hace años, los asiduos de su restaurante, que ofrece delicias selectas en un entorno de agradable sencillez, intentan mantener el lugar en secreto. No quieren compartir la morcilla, el guiso o el aguardiente de frutas.

RESTAURANTS
+CAFÉS

DER GOLDENE HAHN

Pücklerstraße 20 // Kreuzberg
Tel.: +49 (0)30 6 18 80 98
www.goldenerhahn.de

Daily from 7 pm

U1 Görlitzer Bahnhof

Prices: $$$
Cuisine: Italian

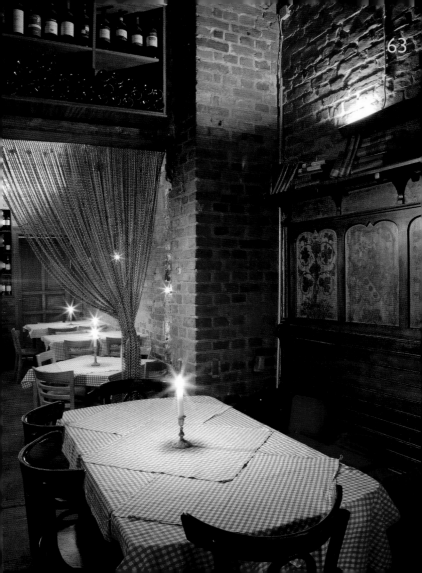

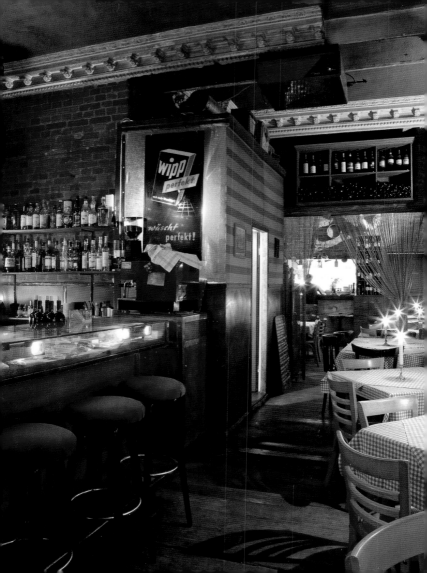

This restaurant's quintessential German name belies the excellent home-style Italian fare you'll find there. Dishes are constantly changing, and the menu is written in Italian on a blackboard and presented at your table. An evening at Felice Caliolo's eatery across from the covered market has huge romantic potential: flattering candlelight, red brick, checkered tablecloths, wine for any palate (and wallet), and the bartender spins records.

Hinter diesem urdeutschen Namen versteckt sich feine italienische Hausmannskost. Die Gerichte variieren ständig, als Speisekarte dient eine abenteuerliche Tafel auf Italienisch, die an den Tisch gebracht wird. Überhaupt hat ein Abend in Felice Caliolos Lokal gegenüber der Markthalle viel romantisches Potenzial: schmeichelndes Kerzenlicht, roter Backstein, gewürfelte Tischdecken, Wein für jeden Gaumen (und Geldbeutel), und der Barmann legt Platten auf.

Derrière ce nom typiquement allemand se cache une cuisine traditionnelle des plus italiennes. La carte, qui est rédigée en italien sur un tableau rocambolesque et vous est présentée à table, est constamment renouvelée. Une soirée dans l'établissement de Felice Caliolo, situé en face de la halle, ne manque pas de romantisme : la lueur des chandelles sur de jolies briques rouges, des nappes à carreaux, du vin pour tous les goûts (et toutes les bourses) et un barman qui passe des vinyle.

Detrás de este típico nombre alemán se esconde una refinada cocina casera italiana. El menú, escrito en italiano, varía en la curiosa pizarra que se lleva a la mesa del comensal a modo de carta. Sin lugar a dudas, las veladas en este local frente al mercado, regentado por Felice Caliolo, poseen un alto factor de romanticismo: luz de velas, ladrillos rojos, manteles a cuadros, vino para todos los gustos (y bolsillos) y un barman que hace a la vez de pinchadiscos.

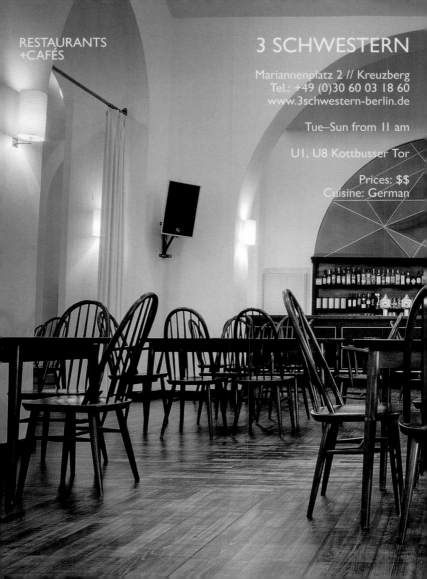

RESTAURANTS
+CAFÉS

3 SCHWESTERN

Mariannenplatz 2 // Kreuzberg
Tel.: +49 (0)30 60 03 18 60
www.3schwestern-berlin.de

Tue–Sun from 11 am

U1, U8 Kottbusser Tor

Prices: $$
Cuisine: German

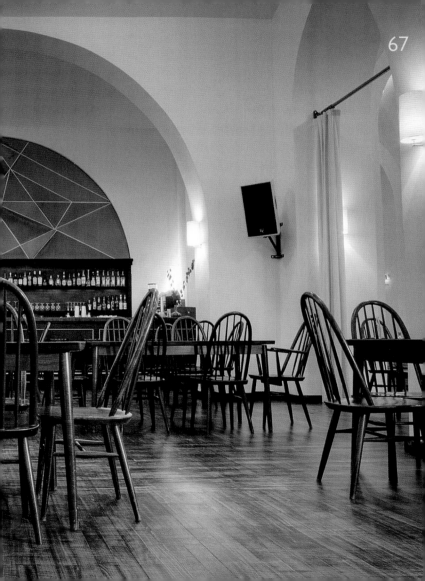

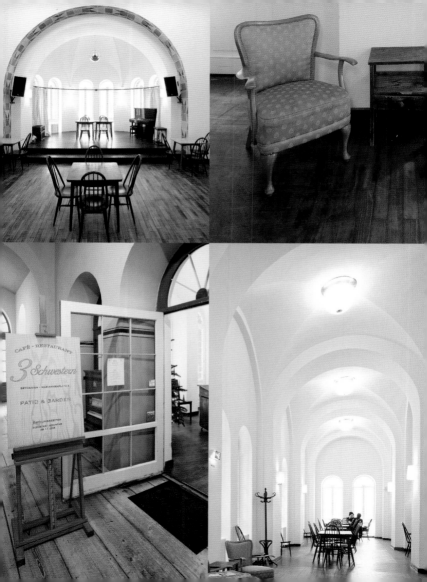

A famous restaurant critic's declaration of love was stormy—and justified. Your heart, eyes, ears, and stomach are pampered in the former deaconesses' dining hall at Kunstquartier Bethanien. Since June 2010, the Sinhart-Böhl team (formerly White Trash and Admiralspalast) has offered "fine food & primitive rock 'n' roll" with plenty of style and no fuss, spilling into the garden in the summer. Inside, bass speakers are rolled out in the evenings, and things can get wild.

Die Liebeserklärung einer bekannten Restaurantkritikerin war stürmisch – und begründet. Im ehemaligen Speisesaal der Diakonissen im Kunstquartier Bethanien werden Herz, Auge, Ohr und Bauch verwöhnt. Seit Juni 2010 bietet das Gespann Sinhart-Böhl (früher White Trash bzw. Admiralspalast) „fine Food & primitive Rock 'n' Roll" mit viel Stil und ohne Getue, im Sommer im Garten. Drinnen werden abends die Bassboxen hereingerollt. Es darf wild werden.

La déclaration d'amour d'une critique gastronomique réputée était enflammée, et fondée. Se restaurer dans l'ancien réfectoire des diaconesses, situé dans le centre culturel Kunstquartier Bethanien, est un plaisir pour l'âme, les yeux, l'ouïe et les papilles. Depuis juin 2010, le tandem Sinhart-Böhl (anciennement White Trash et Admiralspalast), propose « une cuisine raffinée sur un rythme Rock 'n' Roll primitif », avec style et sans chichi. La terrasse est ouverte en été. En soirée, on rentre les baffles à l'intérieur et la fête commence.

La declaración de amor de una conocida crítica gastronómica ha sido apasionada —y merecida. En el antiguo comedor de las diaconisas, ubicado en el "Kunstquartier Bethanien", se mima al comensal en cuerpo y alma. Desde junio de 2010, el dúo Sinhart-Böhl (antiguamente White Trash y Admiralspalast) ofrece con estilo pero sin rodeos "comida selecta y Rock elemental". La terraza abre en verano. Al caer la noche, en el interior se instalan unos potentes altavoces. Excesos permitidos.

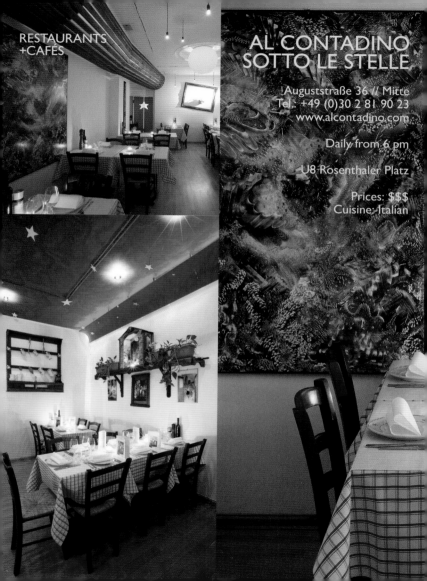

RESTAURANTS
+CAFÉS

AL CONTADINO
SOTTO LE STELLE

Auguststraße 36 // Mitte
Tel.: +49 (0)30 2 81 90 23
www.alcontadino.com

Daily from 6 pm

U8 Rosenthaler Platz

Prices: $$$
Cuisine: Italian

Italians know that being simple yet first-rate is no contradiction in terms. Their peasant cuisine is refined, and mamma can magically transform a few good ingredients into heavenly dishes. This is what you'll find at Contadino, where after enjoying some home-made pasta or something as substantial as oven-braised rabbit with country salami and apples, you'll lean back blissfully, gaze up at the stars, and feel heavenly. Life is beautiful.

Einfach und erstklassig ist kein Widerspruch, die Italiener wissen das. Bei ihnen ist die bäuerliche Küche raffiniert, Mamma zaubert aus wenigen guten Zutaten himmlische Gerichte. So ist das beim freundlichen Contadino, wo man nach dem Genuss der hausgemachten Pasta oder so was Deftigem wie im Ofen geschmorten Kaninchen mit Bauernsalami und Äpfeln selig nach hinten fällt, die Sterne sieht und sich dem Himmel ganz nah fühlt. Das Leben ist schön.

En Italie, excellente qualité rime avec simplicité. Même la cuisine campagnarde italienne est raffinée et la mamma mitonne des mets exquis à base de seulement quelques ingrédients. Vous pouvez vous en rendre compte par vous même en allant déguster chez Contadino les pâtes faites maison ou un autre plat copieux comme le lapin mijoté au saucisson campagnard et aux pommes. Repu, vous vous laisserez tomber sur le dossier de votre chaise en admirant le ciel étoilé et réaliserez combien la vie est belle.

Como bien saben los italianos, lo sencillo y lo exquisito a menudo van de la mano. En su cocina tradicional se logran platos excepcionales con los ingredientes más básicos. Lo mismo sucede en el Contadino, donde después de haber disfrutado de la pasta casera o de algo tan consistente como el conejo al horno con longaniza y manzanas, el comensal se reclina satisfecho para contemplar las estrellas y sentirse en las nubes. La vida es bella.

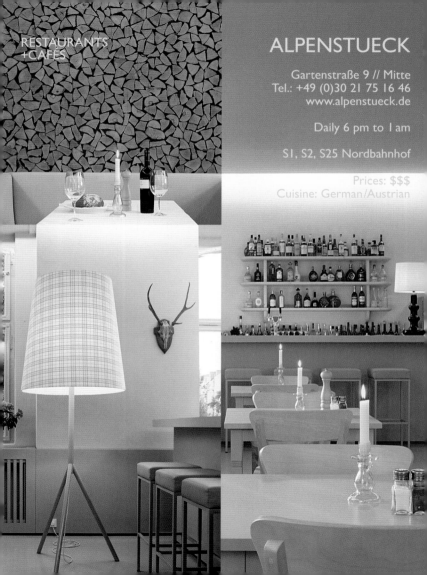

ALPENSTUECK

Gartenstraße 9 // Mitte
Tel.: +49 (0)30 21 75 16 46
www.alpenstueck.de

Daily 6 pm to 1 am

S1, S2, S25 Nordbahnhof

Prices: $$$
Cuisine: German/Austrian

If you enjoy hearty southern German fare but would still like to savor your schnitzel or maultaschen in an ultramodern atmosphere, this is just the spot for you. Vegetarians and calorie-counters have few options, but everyone else can feast with a clear conscience in front of a solid wooden wall: all products have an excellent eco-balance—they come from Berlin's surrounding countryside—and the meat and fish comes from humanely raised animals.

Wer es süddeutsch-deftig liebt und sein Schnitzel oder seine Maultaschen trotzdem gerne in ultramodernem Ambiente verspeist, ist hier genau richtig. Vegetarier und Kalorienzähler haben es schwer, alle anderen können vor der aus Holzscheiten geschichteten Wand mit gutem Gewissen schlemmen: Alle Produkte haben eine ausgezeichnete Ökobilanz – sie kommen aus dem Berliner Umland –, und Fisch und Fleisch stammen von Tieren aus artgerechter Haltung.

Pour ceux qui raffolent de la cuisine consistante du sud de l'Allemagne et ses Schnitzel (escalopes) ou Maultaschen (raviolis souabes), même dans une ambiance ultramoderne. Les végétariens et ceux qui comptent les calories rencontreront quelques difficultés mais les autres pourront festoyer sans mauvaise conscience entre les murs de bûches de bois. Tous les produits présentent un excellent bilan écologique. Ils proviennent de la campagne berlinoise, et la viande et le poisson sont issus d'une agriculture biologique.

Es el lugar idóneo para aquellos que favorecen la generosa cocina típica del sur de Alemania y que, además, desean disfrutar del escalope y de la pasta rellena en un entorno vanguardista. Los vegetarianos y aquellos dados a contar calorías lo tendrán difícil. Todos los demás pueden deleitar su paladar sin escrúpulos delante de la acogedora pared de leña. Cada producto tiene un balance ambiental excelente y proviene de los alrededores de Berlín. La carne y el pescado son de cultivo biológico.

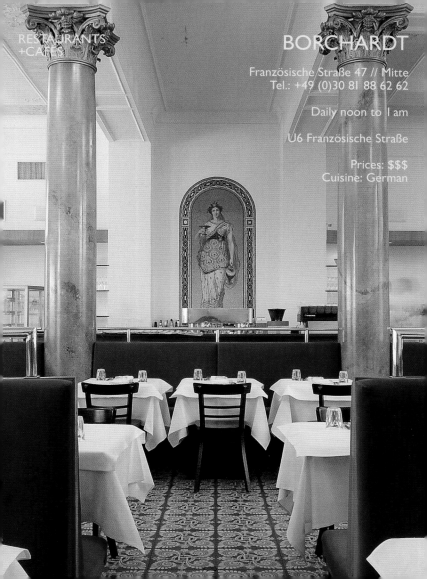

BORCHARDT

Französische Straße 47 // Mitte
Tel.: +49 (0)30 81 88 62 62

Daily noon to 1 am

U6 Französische Straße

Prices: $$$
Cuisine: German

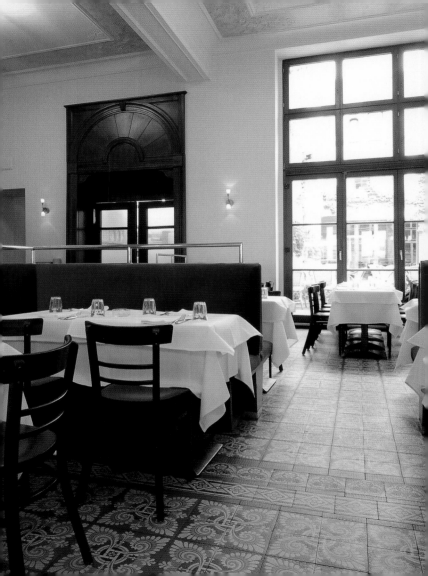

As far back as the late 19th century, class-conscious guests dined in the landmark-protected building on Gendarmenmarkt. Back then the clientele was mostly upper class and aristocratic, while today it tends to be politicians and celebrities. None other than Barack Obama is said to have eaten one of the famous Borchardt schnitzels. The large dining room with its four marble columns and plastered ceilings can get loud and hectic during peak times.

Schon im ausgehenden 19. Jahrhundert speisten im denkmalgeschützten Haus am Gendarmenmarkt standesbewusste Gäste. Während damals vor allem das gehobene Bürgertum und der Adel die Kundschaft ausmachten, kommen heute vornehmlich Politiker und Prominente. Sogar Barack Obama soll schon eines der berühmten Borchardt-Schnitzel verzehrt haben. Im großen Speisesaal mit den vier Marmorsäulen und den Stuckdecken geht es zu Stoßzeiten laut und hektisch zu.

À la fin du 19e siècle, ce restaurant, situé dans un immeuble classé monument historique du Gendarmenmarkt, recevait déjà la haute société de l'époque comme les membres de la haute bourgeoisie et de l'aristocratie. De nos jours, on y rencontre des hommes politiques et personnalités importantes. Barack Obama aurait même déjà dégusté un Schnitzel (escalope panée) de chez Borchardt. Aux heures d'affluence, la grande salle de restaurant aux quatre colonnes de marbre et au plafond en stuc est en pleine effervescence.

Desde finales del siglo XIX, los huéspedes de gran casta se han dado cita a la mesa de esta casa, catalogada como patrimonio nacional y ubicada en la Gendarmenmarkt. Si antaño la clientela se componía de la clase alta y los nobles, hoy son los políticos y famosos los que pueblan sus mesas. Se dice que Barack Obama también degustó aquí uno de los famosos escalopes. Cuando se llena el gran comedor, dotado de cuatro columnas de mármol y techos estucados, el ambiente se vuelve vivo y agitado.

GRILL ROYAL

Friedrichstraße 105 // Mitte
Tel.: +49 (0)30 28 87 92 88
www.grillroyal.com

Daily from 6 pm

S1, S2, S3, S5, S7, S25, S75
U6 Friedrichstraße

Prices: $$$$
Cuisine: German

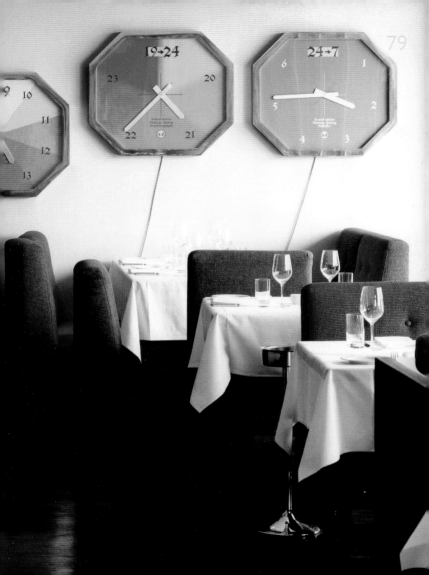

In the summer, this is a delightful spot on the River Spree to relax on soft chairs underneath the awnings and watch the tourist steamboats float by—assuming you're not distracted by a famous face from the movies or television. Celebrities like to come here, too, to relax and enjoy a top-quality steak in elegant surroundings. And there are no secrets regarding the food: products are stored in refrigerated displays and prepared in the open kitchen.

Im Sommer sitzt man auf weichen Sesseln im Schutz der Markisen direkt an der Spree und sieht die Touristendampfer vorbeiziehen. Wenn nicht ein bekanntes Gesicht aus Film und Fernsehen ablenkt. Denn auch Promis kommen gerne hierher, um in stilvoller Umgebung entspannt ein Edelsteak zu verzehren. Diesbezüglich gibt es keine Geheimnisse: Die Produkte werden in Schaukühlschränken offen präsentiert und in der einsehbaren Küche zubereitet.

L'été, assis dans des fauteuils douillets à l'abri d'un auvent au bord du Spree, on voit défiler les bateaux à vapeur touristiques, quand l'attention n'est pas détournée par des visages célèbres. Les stars de la télévision et du cinéma aiment en effet s'y détendre et déguster un bon steak dans un cadre stylé, où rien n'est tenu secret ; tous les produits sont exposés dans des vitrines réfrigérées et cuisinés à la vue de tous.

En verano, las cómodas butacas entoldadas a orillas del río Spree invitan a sentarse y a ver pasar los barcos de turistas —siempre y cuando a uno no le distraigan las caras conocidas del mundo del cine o de la televisión entre los comensales. Porque también los famosos se dan cita aquí para degustar un bistec de primera en un entorno elegante. En cuanto a los productos, no hay secretos; están expuestos en neveras escaparates y se elaboran en la cocina abierta a ojos del público.

LA BONNE
FRANQUETTE

Chausseestraße 110 // Mitte
Tel.: +49 (0)30 94 40 53 63
www.labonnefranquette.de

Mon–Fri 11:30 am to 3 pm
Mon–Sat from 6:30 pm

U6 Naturkundemuseum

Prices: $$
Cuisine: French

La cuisine mijote ses secrets savour

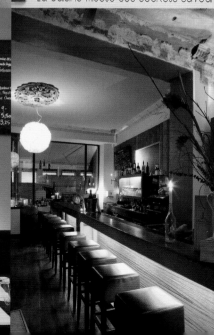

It's a good thing this place is a little off the beaten path, otherwise before long you'd never be able to get a table. This brasserie is nicely uncomplicated—cozy but not overloaded—and the classic French cuisine is an utter pleasure. The lunch menu has unbeatable prices; add to that the charm of the bilingual team led by hosts Jana and François, top it off with good wine, and you'll see that this place is too good to stay a secret for long.

Wie gut, dass dieser Ort ein wenig ab vom Schuss liegt. Denn sonst würde man bald überhaupt keinen Tisch mehr bekommen. Die Brasserie ist sympathisch unkompliziert, gemütlich, aber nicht überladen; das Essen (französische Klassiker) durchweg ein Genuss. Unschlagbar günstig obendrein ist das Mittagsmenü. Dazu kommt der Charme des zweisprachigen Teams um Gastgeber Jana und François. Und guter Wein. Zu schön, um Geheimtipp zu sein.

Heureusement que cet établissement est situé un peu en recul, sinon vous n'auriez jamais la chance d'obtenir une table. La brasserie est agréable, confortable et décorée sobrement. La cuisine française classique qu'on y sert est un vrai délice. Le prix du repas du midi défie toute concurrence. De plus, le bon vin et le charme de l'équipe bilingue et des maîtres de maison, Jana et François, n'auront de cesse de vous séduire. Impossible de garder ce lieu secret.

Menos mal que este lugar está un poco apartado del bullicio, porque si no, ya no habría mesa libre nunca. El café-restaurante defiende un estilo discreto y acogedor sin excesos. La carta se compone de clásicos de la cocina francesa y cada plato es un auténtico deleite. Hay un menú de mediodía a un precio incomparable. Cuando a esto se le añade un buen vino y el encanto del equipo bilingüe de Jana y François se llega a entender por qué este local no podrá mantenerse en secreto.

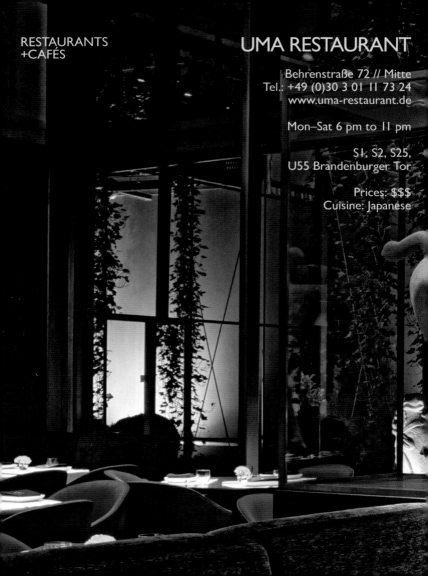

RESTAURANTS
+CAFÉS

UMA RESTAURANT

Behrenstraße 72 // Mitte
Tel.: +49 (0)30 3 01 11 73 24
www.uma-restaurant.de

Mon–Sat 6 pm to 11 pm

S1, S2, S25,
U55 Brandenburger Tor

Prices: $$$
Cuisine: Japanese

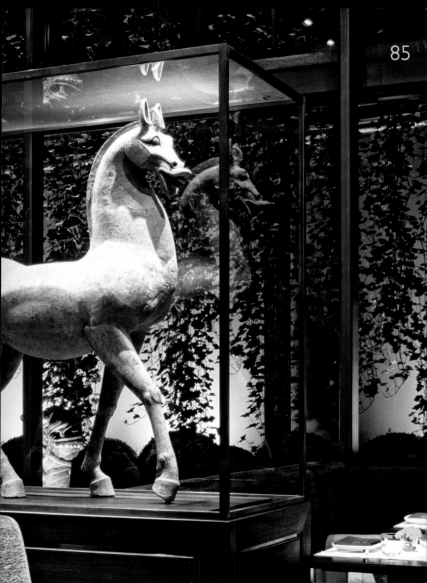

The best of China and Japan join forces on Behrenstraße behind the Hotel Adlon. UMA's name pays homage to Tim Raue's former restaurant, MA. Upon entering, you can't miss a mighty clay horse from the Han Dynasty in the middle of the room. Behind a large glass window, chef Stephan Zuber creates modern Japanese cuisine that challenges the European palate without demanding too much of it. Despite the exclusive atmosphere, you're sure to have a great time.

In der Behrenstraße, hinter dem Adlon, verbinden sich China und Japan im besten Sinne. Mitten im UMA, in dem buchstäblich das Ex-MA von Tim Raue steckt, thront mächtig ein tönernes Pferd aus der Han-Dynastie. Hinter dem großen Glasfenster kreiert Küchenchef Stephan Zuber moderne japanische Küche, die den europäischen Gaumen herausfordert, ohne ihm zu viel abzuverlangen. Trotz des edlen Ambientes kann man sich hier durchaus gesellig amüsieren.

Dans ce restaurant situé dans la Behrenstraße, derrière l'hôtel Adlon, la Chine et le Japon s'accordent en parfaite harmonie. Au centre du UMA, l'ancien restaurant MA du Tim Raue, s'élève un cheval de glaise de l'époque de la dynastie Han. La cuisine est située derrière une grande baie vitrée, où le grand chef Stephan Zuber met les palais européens au défi, sans pour autant les mettre à l'épreuve, en créant des plats modernes aux saveurs japonaises. Un lieu à ambiance noble pour passer un moment agréable et divertissant.

En la Behrenstraße, a espaldas del hotel Adlon, China y Japón se fusionan a la perfección. En medio del UMA, cuyo nombre literalmente conserva el antiguo MA de Tim Raue, se alza un monumental caballo de barro de la dinastía Han. Detrás de los grandes ventanales, el chef Stephan Zuber prepara platos japoneses modernos que retan al paladar europeo sin exigirle demasiado. A pesar del aire lujoso, este restaurante también es un lugar donde pasar una divertida velada entre amigos.

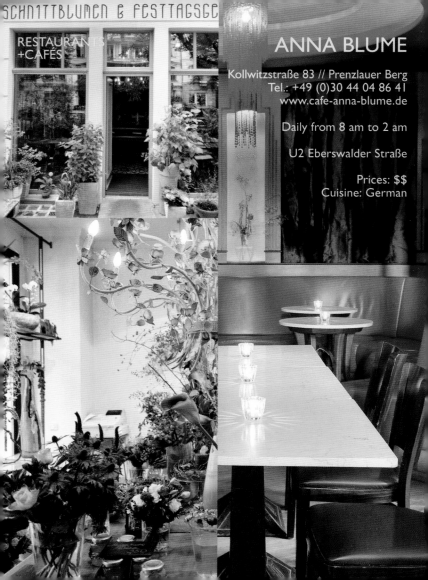

SCHNITTBLUMEN & FESTTAGSGE

RESTAURANTS
+CAFÉS

ANNA BLUME

Kollwitzstraße 83 // Prenzlauer Berg
Tel.: +49 (0)30 44 04 86 41
www.cafe-anna-blume.de

Daily from 8 am to 2 am

U2 Eberswalder Straße

Prices: $$
Cuisine: German

"Oh, thou most beloved of my 27 senses..."—
Kurt Schwitters waxed lyrical in a poem to his beloved
Anna Blume. This corner café with adjoining flower shop
on Kollwitzstraße serves up culinary and floral delights
in an effort to spoil guests in every way possible. In the
summer, this is a perfect place to eat breakfast outdoors
and watch people go by. Inside, don't miss the lovely art
deco furnishings and the flower girl mural by Mucha.

„Oh Du, Geliebte meiner 27 Sinne ..." – so schwärmerisch
dichtete Kurt Schwitters über seine geliebte Anna Blume.
Sehr sinnlich geht es im gleichnamigen Eckcafé mit ange-
schlossenem Blumenladen in der Kollwitzstraße zu, das
den Gast auf allen Sinnesebenen kulinarisch und floristisch
verwöhnt. Im Sommer frühstückt man wunderbar draußen
und beobachtet die Menschen. Drinnen locken die schöne
Art-déco-Einrichtung und das Blumenmädchen von Mucha.

« Ô toi, la plus aimée de mes 27 sens... », ainsi commence
le poème d'amour de Kurt Schwitter à sa bien-aimée
Anna Blume. C'est avec la même volupté que sont reçus
les clients dans ce café du même nom et la boutique de
fleurs attenante au coin de la Kollwitzstraße, où ils suc-
combent au plaisir des sens en dégustant des spécialités
culinaires dans un beau cadre floral. En été, sur la terrasse,
on peut prendre son petit déjeuner tout en observant
les passants. L'intérieur art déco et la jeune fille aux fleurs
de Mucha en séduiront plus d'un.

"Oh tú, amada de mis 27 sentidos..." —así de entusiasmado
recitaba Kurt Schwitters sobre su amante Anna Blume.
El café del mismo nombre en la Kollwitzstraße, con
floristería contigua, mima con su sensual ambiente
todos los sentidos de sus huéspedes, tanto culinaria
como floralmente. En verano se desayuna estupenda-
mente fuera, observando a la gente. En el interior
seducen la preciosa decoración art déco y la niña de
las flores de Mucha.

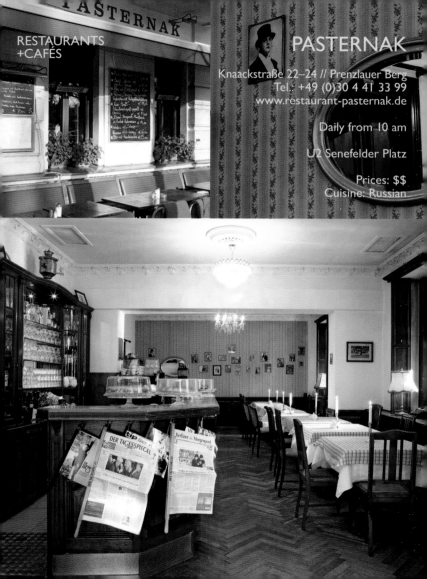

RESTAURANTS
+CAFÉS

PASTERNAK

Knaackstraße 22–24 // Prenzlauer Berg
Tel.: +49 (0)30 4 41 33 99
www.restaurant-pasternak.de

Daily from 10 am

U2 Senefelder Platz

Prices: $$
Cuisine: Russian

If you had a Russian grandmother, this is what a visit to her house would feel like. And Pasternak does indeed have a cherry strudel, or fluden, made by grandma. If you can manage it, that is, since you've already had the "Proletariat" plate (naturally with double vodka), a bowl of borscht, and Jewish latkes. The establishment is named after Boris Pasternak, who as the author of "Doctor Zhivago" was celebrated internationally but fell out of grace in Russia.

Hätte man eine russische Großmutter – so würde sich ein Besuch bei ihr anfühlen. In der Tat gibt es im Pasternak einen von Oma gemachten Kirschstrudel, den Fluden. Wenn der noch reinpasst, denn davor hatte man den Teller „Proletariat", mit doppeltem Wodka versteht sich, eine Portion Borschtsch und jüdische Latkes. Namenspatron ist Boris Pasternak, der als Autor von „Doktor Schiwago" international gefeiert wurde, in Russland jedoch in Ungnade fiel.

Si votre grand-mère était russe, vous vous sentiriez chez elle. Chez Pasternak, vous pouvez en effet déguster le fluden, un excellent strudel aux cerises d'après une recette de grand-mère, si vous n'êtes pas déjà rassasié après une assiette « prolétariat » et une double vodka, une portion de borschtsch et des galettes de pomme de terre façon juive (latkes). Le saint patron de cet établissement est Boris Pasternak, qui n'est autre que l'auteur de « Le Docteur Jivago », célébré à l'échelle internationale et pourtant tombé en disgrâce en Russie.

De tener una abuela rusa, seguro que ir a visitarla sería así. De hecho, la carta de este restaurante incluye un pastel casero de cerezas de la abuela, el fluden. El comensal decidirá si aún le hará un hueco a este manjar tras haber probado el "Proletariado"—plato acompañado, cómo no, de dos chupitos de vodka, una ración de borsch y unos latkes judíos. El nombre se toma de Boris Pasternak, aclamado a nivel internacional por su novela "Doctor Zhivago" pero caído en desgracia en su Rusia natal.

SHOPS

AUFRAUSCH

COOL
BERLIN

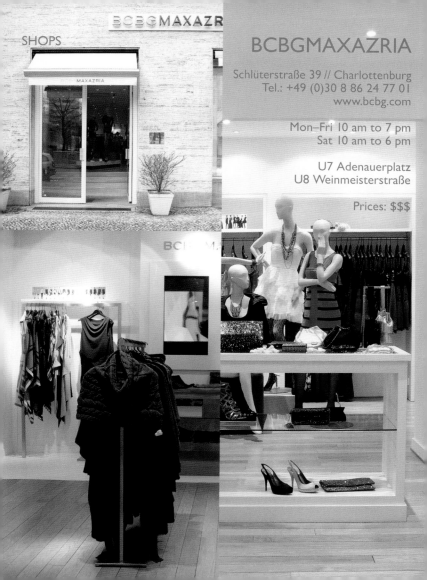

SHOPS

BCBGMAXAZRIA

Schlüterstraße 39 // Charlottenburg
Tel.: +49 (0)30 8 86 24 77 01
www.bcbg.com

Mon–Fri 10 am to 7 pm
Sat 10 am to 6 pm

U7 Adenauerplatz
U8 Weinmeisterstraße

Prices: $$$

Behind the four letters is Max Azria, a Tunisian-French-American fashion designer who has been making many women happy with his creations since starting the label in 1989. Famous divas such as Halle Berry and Angelina Jolie love his designs, as do the women in Berlin. They receive personal consultation and service at the boutique on Schlüterstraße, and afterwards they can take their dream dresses home with them.

Hinter den vier Buchstaben steht Max Azria, ein tunesisch-französisch-amerikanischer Modedesigner, der seit der Labelgründung 1989 viele Frauen mit seinen Kreationen glücklich macht. Berühmte Diven, wie Halle Berry und Angelina Jolie, lieben seine Entwürfe, ebenso wie die Berliner Frau. Sie kann sich in der Boutique in der Schlüterstraße sehr persönlich beraten und bedienen lassen und am Ende ihr Traum-kleid mit nach Hause nehmen.

Derrière ces quatre lettres se cache Max Azria, ce styliste d'origine tuniso-franco-américaine qui, depuis la création de sa marque en 1989, comble de bonheur bon nombre de femmes. Ses croquis sont appréciés autant par des stars comme Halle Berry et Angelina Jolie que par les Berlinoises. Dans la boutique de la Schlüter-straße, une équipe professionnelle les conseille per-sonnellement. Elles repartent ensuite avec la robe de leurs rêves.

Tras estas iniciales se esconde Max Azria, un diseñador de moda con raíces tunecinas, francesas y americanas. Desde la fundación de la marca en 1989, Azria ha hecho felices a muchas mujeres con sus creaciones. Ya sean las célebres divas como Halle Berry y Angelina Jolie o las clientas berlinesas, todas adoran las prendas de BCBG. En la boutique de la Schlüterstraße los clientes obtienen un servicio muy personal y pueden adquirir vestidos de ensueño.

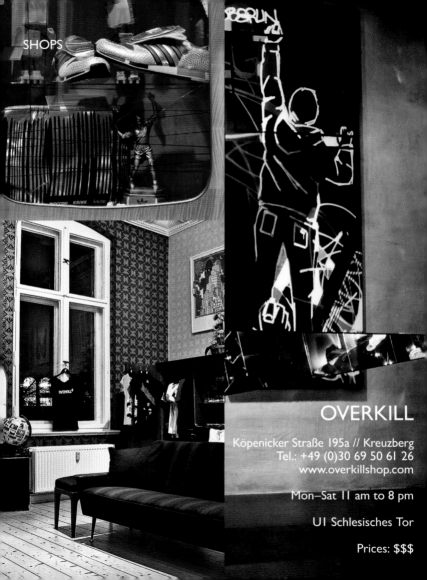

OVERKILL

Köpenicker Straße 195a // Kreuzberg
Tel.: +49 (0)30 69 50 61 26
www.overkillshop.com

Mon–Sat 11 am to 8 pm

U1 Schlesisches Tor

Prices: $$$

In 2008 the store at Schlesisches Tor died a public death—
only to then emerge spectacular, big and radiant at five times
its former size. Named after one of Berlin's first graffiti
magazines to come out in the early 90s, Overkill has been
synonymous with Hip Hop ever since, yet it has kept up
with the times. Nowadays the name expresses the feeling
that comes over you during a shopping spree as you stare
at a wall of sneakers in a mirrored room.

2008 starb der Laden am Schlesischen Tor demonstrativ
einen öffentlichen Tod. Um dann spektakulär, groß und
glänzend auf fünffacher Fläche seine Auferstehung zu feiern.
Overkill steht seit seiner Geburt in den frühen Neunzigern
als Name eines Berliner Graffitimagazins für Hip Hop, ist
aber mit der Zeit gegangen. Heute verleiht der Name dem
Gefühl des Kaufrauschs Ausdruck, das einen überfällt, wenn
man im verspiegelten Raum vor der Sneakerwand steht.

Après une disparition remarquée en 2008, le
magasin du Schlesisches Tor est réapparu dans toute
sa splendeur et son faste sur une surface cinq fois plus
grande. Au début des années 90, Overkill était le nom
d'un magazine berlinois de graffitis hip-hop. De nos
jours, ce nom est synonyme de fièvre acheteuse, cette
fièvre qui vous gagne lorsque vous vous aventurez
dans la salle aux miroirs en face du mur de sneakers.

En 2008, la tienda junto a la Schlesisches Tor pareció
por fin sucumbir a su muerte anunciada para después
volver a abrir sus puertas y reaparecer de manera
espectacular, con una superficie cinco veces mayor a
la antigua. El nombre Overkill, tomado de un fanzine
de grafiti hip hop de los 90, ha evolucionado con el
paso del tiempo y se asocia hoy más bien a la fiebre
de compras que le entra a uno al ver la pared llena de
zapatillas en la sala de paredes de espejo.

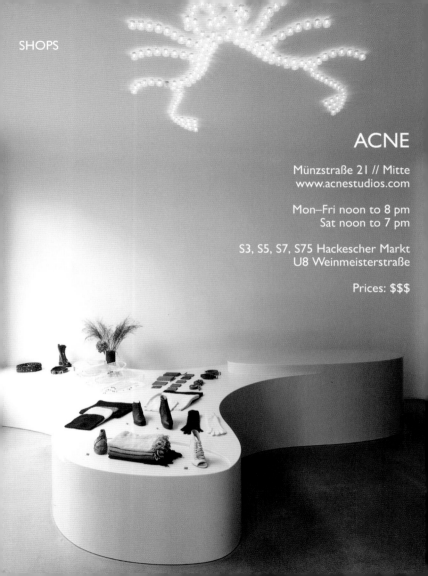

ACNE

Münzstraße 21 // Mitte
www.acnestudios.com

Mon–Fri noon to 8 pm
Sat noon to 7 pm

S3, S5, S7, S75 Hackescher Markt
U8 Weinmeisterstraße

Prices: $$$

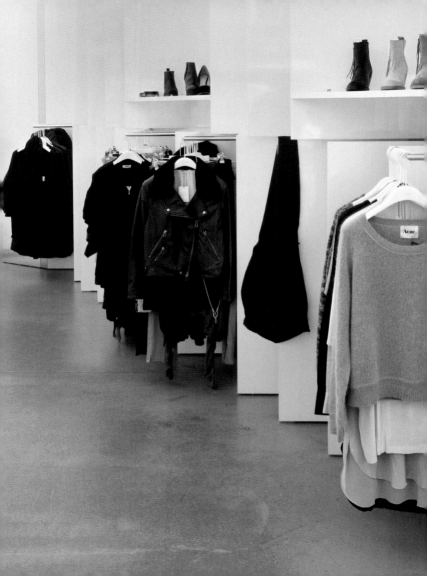

ACNE's triumphant march of high-rise skinny jeans started in 1996 with just 100 pairs of unisex jeans. Since then the design spectrum of the Stockholm brand has broadened to include shirts, jackets, shoes, and assorted accessories. Naturally everything reflects the discreet understatement of the Swedes, also apparent in the shop on Münzstraße. It plays with clarity, pastels, and amorphous shapes; its minimalism suits the Mitte district.

Der Siegeszug der hoch geschnittenen Röhre fing 1996 mit 100 Paar Unisex-Jeans an. Mittlerweile hat sich das Designspektrum der Stockholmer Marke auf Shirts, Jacken, Schuhe und verschiedene Accessoires erweitert. Alles spiegelt selbstverständlich das dezente Understatement der Schweden wider, so zu sehen auch im Shop in der Münzstraße. Der spielt mit Klarheit, Pastellfarben und amorphen Formen. Ein Mitte-freundlicher Minimalismus.

TITA VON HARDENBERG'S SPECIAL TIP

Though the name takes some getting used to, it stands for the best-fitting jeans in the country—and they're always long enough.

Avec 100 paires de modèles unisexe, les pantalons « tuyau-de-poêle » à taille haute sont arrivés en force en 1996 dans cette boutique de mode. La marque stockholmienne a entre-temps élargi l'éventail de sa collection design : T-shirts, vestes, chaussures et accessoires. Chaque modèle reflète le minimalisme cher aux Suédois, comme vous pouvez le voir dans la boutique de la Münzstraße, où le décor associe clarté, couleurs pastel et formes nonchalantes. Un délicieux monde minimaliste au cœur de Berlin.

El triunfo de los vaqueros estrechos con cintura alta empezó en 1996 con 100 pantalones unisex. Entretanto, los diseños de la firma de Estocolmo también incluyen camisas, chaquetas, zapatos y varios tipos de accesorios. Por supuesto, todo acorde al estilo sencillo pero elaborado de la casa sueca, que cuenta con una boutique en la Münzstraße. En este comercio se compaginan la luminosidad, los colores pastel y las formas abstractas. Un minimalismo muy al estilo del barrio de Berlín-Mitte.

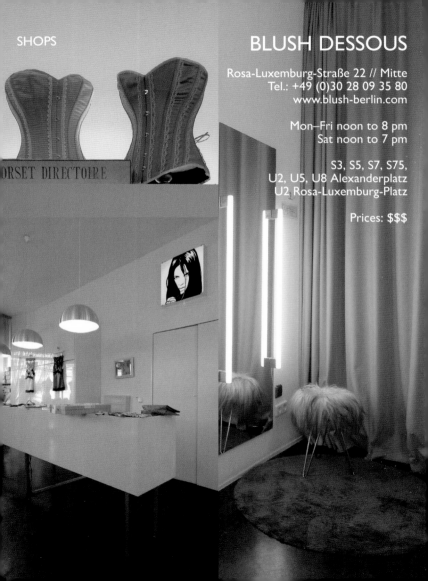

BLUSH DESSOUS

Rosa-Luxemburg-Straße 22 // Mitte
Tel.: +49 (0)30 28 09 35 80
www.blush-berlin.com

Mon–Fri noon to 8 pm
Sat noon to 7 pm

S3, S5, S7, S75,
U2, U5, U8 Alexanderplatz
U2 Rosa-Luxemburg-Platz

Prices: $$$

The Mitte district has, on average, almost three more births per 1,000 residents than the rest of Berlin. At Blush this is attributed with a confident wink to the nine-year existence of the shop by women for women with the stated goal of bringing "more love into the world." Lingerie and other flattering garments are a sensual means to an end. The woman in charge is not a former model but Claudia Kleinert, textile professional and mother of three.

In Mitte kommen auf 1000 Einwohner im Schnitt fast drei Neugeborene mehr als im Rest Berlins. Bei Blush führt man das – selbstbewusst und humorvoll – auf das neunjährige Bestehen des Shops von Frauen für Frauen mit dem erklärten Ziel, „mehr Liebe in die Welt" zu bringen, zurück. Sinnliche Mittel zum Zweck sind Dessous und andere Körperschmeichler. Dahinter steckt kein Ex-Model, sondern Claudia Kleinert, Textilprofi und Mutter dreier Kinder.

Dans le centre de Berlin, le taux moyen de natalité, environ trois nouveau-nés pour 1 000 habitants, est plus élevé que dans les autres quartiers de la capitale. L'objectif principal de Blush, boutique créée il y a neuf ans par des femmes pour des femmes, est de donner, avec humour et assurance, « plus d'amour au monde ». À cet effet, Claudia Kleinert, qui n'est pas un ancien manne-quin, mais une professionnelle du textile mère de trois enfants, propose de jolis dessous affriolants et enjôleurs.

En el barrio de Berlín-Mitte hay tres veces más recién nacidos por cada 1 000 habitantes que en cualquier otra zona de la ciudad. La boutique Blush, pensada por y para mujeres, y cuyo objetivo manifiesto es "traer más amor al mundo", se atribuye con humor este mérito tras sus nueve años de existencia. Los sensuales medios para conseguir tal logro son la lencería y otras prendas favorecedoras. La propietaria no es una ex-modelo sino Claudia Kleinert, experta textil y madre de tres hijos.

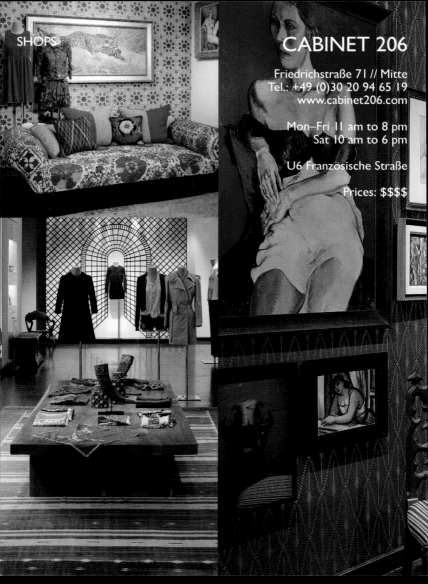

SHOPS

CABINET 206

Friedrichstraße 71 // Mitte
Tel.: +49 (0)30 20 94 65 19
www.cabinet206.com

Mon–Fri 11 am to 8 pm
Sat 10 am to 6 pm

U6 Französische Straße

Prices: $$$$

The Jagdfeld's modern day cabinet of curiosities at Quartier 206 covers 4,800 square feet. This mother-and-son team has a knack for combining select pieces from international labels with antiques and curios. Mismatched ornaments, opulent colors, and art objects perfect the impression that you've somehow landed in the treasure room of a (shopping) fairy tale. Before you know it, you'll have ransacked the place like Ali Baba and the Forty Thieves!

Über 450 Quadratmeter erstreckt sich das Raritäten-kabinett von Mutter und Sohn Jagdfeld im Quartier 206. Die ausgesuchten Stücke internationaler Labels treten mit einer Vielzahl an Antiquitäten und Kuriositäten in Dialog. Widersprüchliche Ornamente, opulente Farben und Kunstobjekte vollenden den Eindruck, in der Schatz-kammer eines (Einkaufs-)Märchens gelandet zu sein. Ehe man sich's versieht, hat man geplündert wie Ali Baba und die 40 Räuber.

Ce repère de curiosités, qui s'étend sur une surface de 450 mètres carrés dans le Quartier 206, est tenu par les Jagdfeld, mère et fils. Cette grande boutique est un véritable théâtre mettant en scène des pièces de marques internationales, des antiquités et diverses curiosités. La décoration paradoxale, les couleurs exubérantes et les œuvres d'art vous donneront l'impression de faire vos emplettes dans la salle aux trésors d'un conte de fée. Sans s'en rendre compte, on se retrouve à piller la caverne d'Ali Baba.

El Quartier 206, regentado por la Sra. Jagdfeld y su hijo, es un auténtico baúl de curiosidades de 450 metros cuadrados. Aquí, las prendas selectas de marcas interna-cionales entablan diálogo con las numerosas antigüedades y piezas únicas. Los contradictorios ornamentos, suntuosos colores y objetos de arte terminan por convencer al cliente de que ha dado con la cámara del tesoro de un cuento (de compras). Antes de que se dé cuenta habrá saqueado la tienda como Alí Babá y los 40 ladrones.

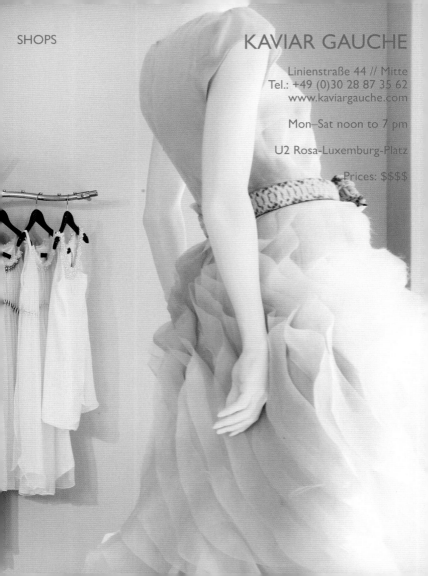

KAVIAR GAUCHE

Linienstraße 44 // Mitte
Tel.: +49 (0)30 28 87 35 62
www.kaviargauche.com

Mon–Sat noon to 7 pm

U2 Rosa-Luxemburg-Platz

Prices: $$$$

Feminine, classy, with just a hint of subversiveness—
the two Berlin designers at Kaviar Gauche, Alexandra
Fischer-Roehler and Johanna Kühl, wrap strong women
in delicate garments. Their definition of "feminine cool"
perfectly suits the tastes of many actresses, and now
you can visit their new flagship store in the Mitte district
and see for yourself. Future brides can pick dresses from
the tree sculpture.

Weiblich, edel, mit dem Hauch einer subversiven Note –
die beiden Berliner Designerinnen von Kaviar Gauche,
Alexandra Fischer-Roehler und Johanna Kühl, hüllen starke
Frauen in zarte Gewänder. Ihre Definition von „femininer
Coolness", die den Geschmack zahlreicher Schauspielerin-
nen trifft, ist nun auch im neuen Flagship-Store in Mitte
zu besichtigen. Dort kann sich die zukünftige Braut ihr
Kleid von der Baumskulptur pflücken.

TITA VON HARDENBERG'S
SPECIAL TIP

The best wedding
dresses in Berlin.
Also an important address
for fashion-conscious
career women.

Féminité, élégance avec un soupçon de subversion.
Les deux stylistes berlinoises de cette boutique,
Alexandra Fischer-Roehler et Johanna Kühl, enveloppent
leurs clientes – des femmes à forte personnalité – de
robes aériennes. Leur concept de « nonchalance féminine »,
qui correspond au goût d'une multitude d'actrices,
est également à découvrir dans le nouveau magasin
phare du centre. Une sculpture en forme d'arbre
déploie de superbes robes pour les futures mariées.

Suave y elegante pero con cierto aire subversivo:
Alexandra Fischer-Roehler y Johanna Kühl, las dos
diseñadoras berlinesas de Kaviar Gauche, visten a
mujeres de fuerte personalidad con prendas delicadas.
Su definición del descaro femenino está en línea con
el gusto de muchas actrices y se expone ahora también
en su boutique insignia en el centro. Allí, las futuras
novias pueden recolectar sus trajes de una escultura
en forma de árbol.

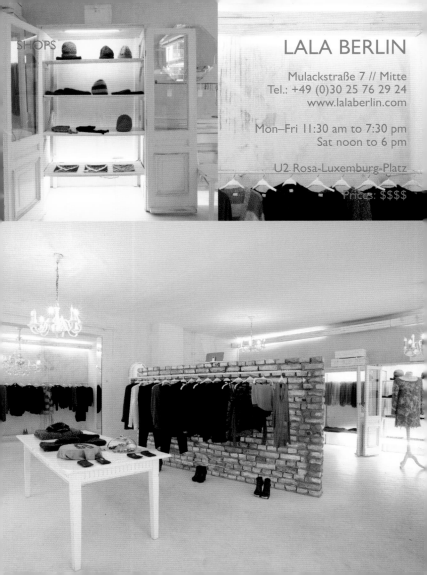

LALA BERLIN

Mulackstraße 7 // Mitte
Tel.: +49 (0)30 25 76 29 24
www.lalaberlin.com

Mon–Fri 11:30 am to 7:30 pm
Sat noon to 6 pm

U2 Rosa-Luxemburg-Platz

Prices: $$$$

Long before knitting became fashionable, Leyla Piedayesh switched from MTV to knitting needles and founded her label, lala Berlin. Since her products were not thick, scratchy scarves but rather light, flattering knitwear of the finest materials, demand grew quickly. Although she can no longer make everything herself, you can wear lala from head to toe. You can even have garments custom-made in the shop on Mulackstraße.

Lange bevor das Stricken schick wurde, wechselte Leyla Piedayesh von MTV an die Nadeln und gründete ihr Label lala Berlin. Da es sich bei ihren Produkten nicht um dicke Kratzschals handelt, sondern um leichten, schmeichelnden Edelstrick aus feinsten Materialien, stieg die Nachfrage rasch. Heute kann sie nicht mehr alles selbst fertigen, dafür gibt es lala von Kopf bis Fuß. Im Shop in der Mulackstraße bekommt man die feinen Teile sogar nach Maß.

Bien avant que le tricotage ne devienne chic, Leyla Piedayesh a abandonné MTV pour des aiguilles et créé sa marque lala Berlin. Comme ses tricots sont des modèles élégants, légers, enjôleurs et d'excellente qualité, bien loin des écharpes râpeuses, leur succès est retentissant, à tel point qu'elle ne peut aujourd'hui plus tout confectionner elle-même. En revanche, vous pourrez vous y habiller de la tête au pied. La boutique de la Mulackstraße vous propose même les modèles les plus chics sur mesure.

Mucho antes de que el punto se pusiese de moda, Leyla Piedayesh dejó la emisora MTV por la aguja y creó la marca lala Berlin. Y porque sus productos no eran bufandas gruesas que pican, sino favorecedoras piezas de punto fino de gran calidad, la demanda aumentó rápidamente. Hoy, ella misma ya no puede elaborarlo todo personalmente pero su colección comprende artículos para enfundarse de lala desde la cabeza hasta los pies. En la boutique de la Mulackstraße se pueden encargar prendas a medida.

WUNDERKIND
VINTAGE

Tucholskystraße 36 // Mitte
Tel.: +49 (0)30 28 04 18 17
www.wunderkind.com

Tue–Sat 11 am to 7 pm

S1, S2, S25 Oranienburger Straße

Prices: $$$$

The boutique at the Gendarmenpalais is spectacular, of course. That's where wunderkind Wolfgang Joop himself, together with Edwin Lemberg, created an artful mini-version of Villa Wunderkind in Potsdam. But Wunderkind Vintage on Tucholskystraße is a real treasure: here in a pure and airy atmosphere you will find collection elements that are at least two seasons old and individual pieces that never went into production.

Natürlich ist die Boutique am Gendarmenpalais spektakulär. Dort hat ja auch Wunderkind Wolfgang Joop persönlich, gemeinsam mit Edwin Lemberg, eine kunstvolle Miniversion der Villa Wunderkind in Potsdam geschaffen. Doch die Vintage Boutique in der Tucholskystraße ist ein wahrer Schatz: In purer, luftiger Atmosphäre findet man hier Kollektionselemente, die mindestens zwei Saisons alt sind, und einzelne, nie in Produktion gegangene Schmuckstücke.

La boutique du Gendarmenpalais est à couper le souffle. L'enfant prodige, Wolfgang Joop, a lui-même conçu, avec la collaboration d'Edwin Lemberg, cette version artistique miniature de la villa Wunderkind à Potsdam. Quand on pénètre dans la boutique Vintage de la Tucholskystraße, on découvre un véritable trésor. Dans une atmosphère légère et naturelle, on y trouve des modèles de collection d'au moins deux saisons et des pièces uniques.

Sin lugar a dudas, la boutique en el edificio Gendarmen-palais es espectacular. Allí, el mismo Wolfgang Joop creó, junto con Edwin Lemberg, una lograda versión en miniatura de la lujosa mansión Wunderkind ubicada en Potsdam. Pero la boutique vintage en la Tucholskystraße es una verdadera joya. Emana un aire puro y limpio y ofrece prendas de colección de al menos dos temporadas de antigüedad, además de piezas únicas.

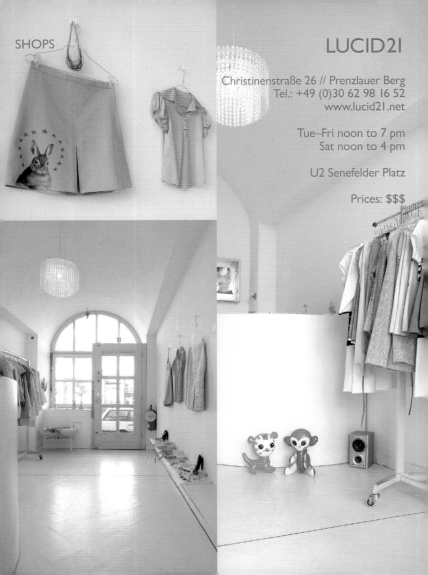

SHOPS

LUCID21

Christinenstraße 26 // Prenzlauer Berg
Tel.: +49 (0)30 62 98 16 52
www.lucid21.net

Tue–Fri noon to 7 pm
Sat noon to 4 pm

U2 Senefelder Platz

Prices: $$$

Fashions by Luis Gunsch and Stefan Münzenmaier evoke fairy tales and girlhood. The creations by the designers and operators of the label revive childhood memories from the 50s to the 70s, and are at once romantic and current. Modern princesses are guaranteed to make finds in the small flagship store on Christinenstraße. In addition to playful feminine robes with braids and colorful prints, you will also find basics such as T-shirts, pants and jackets.

Märchen- und mädchenhaft ist die Mode von Luis Gunsch und Stefan Münzenmaier. Die Entwürfe der Designer und Betreiber des Labels lassen Kindheitserinnerungen der 50er bis 70er aufleben und sind gleichzeitig romantisch und aktuell. Moderne Prinzessinnen werden im kleinen Flagship-Store in der Christinenstraße garantiert fündig. Neben weiblich-verspielten Gewändern mit Borten und farbenfrohen Drucken gibt es Basics wie T-Shirts, Hosen und Jacken.

La mode des créateurs Luis Gunsch et Stefan Münzenmaier est digne des contes de fées. Leurs créations font revivre les souvenirs d'enfance des années 50 à 70, tout en restant romantiques et actuelles. Les princesses des temps modernes trouveront leur bonheur dans le magasin phare de la Christinenstraße. La collection compte des robes féminines aux motifs colorés et galons, mais également des t-shirts, pantalons et vestes plus basiques.

La moda de Luis Gunsch y Stefan Münzenmaier es de fábula y de niña. Las creaciones de los diseñadores y directores de la marca reviven memorias de la niñez de los años 50 hasta los 70 y son, al mismo tiempo, románticas y actuales. Las princesas modernas encontrarán con seguridad lo que buscan en la pequeña tienda de la Christinenstraße, la boutique insignia de la marca. Junto a vestidos de alegre feminidad, con ribetes y estampados de colores vivos, se encuentran basics como camisetas, pantalones y chaquetas.

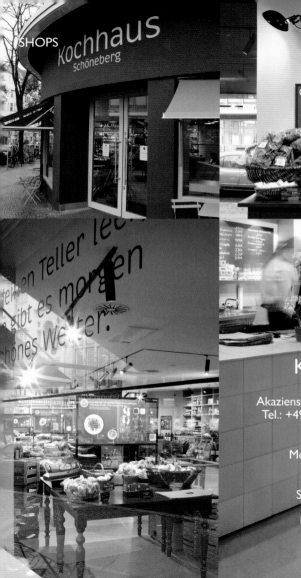

KOCHHAUS

Akazienstraße 1 // Schöneberg
Tel.: +49 (0)30 5 77 08 91 00
www.kochhaus.de

Mon–Fri 10 am to 9 pm
Sat 9 am to 8 pm

S1 Julius-Leber-Brücke
U7 Kleistpark
U7 Eisenacher Straße

Prices: $$

It truly is like walking through a beautiful and highly appetizing cookbook. The ingredients for each recipe are lovingly arranged on dark wood tables, down to the last detail. Above each is a display board that clearly states the degree of difficulty, preparation time, price, and required amount per person. You will find wine recommendations as well. The entire staff is fired up about this terrific idea.

Es ist tatsächlich so, als ob man ein wunderschön gestaltetes, ausgesprochen appetitliches Kochbuch begeht. Die Zutaten eines jeden Rezepts sind bis ins letzte Detail liebevoll auf dunklen Holztischen arrangiert. Darüber prangt jeweils eine Tafel, die übersichtlich den Schweregrad, die Zubereitungszeit, den Preis und die benötigte Menge pro Person erklärt. Den passenden Wein dazu gibt es auch. Alle Mitarbeiter brennen zu Recht für diese großartige Idee.

C'est comme si l'on pénétrait dans un beau livre de cuisine qui met l'eau à la bouche. Les ingrédients de chaque recette y sont présentés avec style et en détail sur des tables de bois sombre au-dessus desquelles trône un tableau indiquant le niveau de difficulté, le temps de préparation, le prix et la quantité par personne ainsi que le vin conseillé. Tous les employés ont bien raison de s'enflammer pour ce concept grandiose.

Es como sumergirse en un libro de cocina especialmente bonito y apetitoso. Los ingredientes de cada receta están colocados con mimo en mesas de madera oscura. Sobre ellas, una pizarra indica la dificultad de elaboración, el tiempo de preparación, el precio y la cantidad prevista por comensal. Tampoco faltan los vinos correspondientes. Todos los empleados defienden con entusiasmo este maravilloso concepto.

CLUBS, LOUNGES +BARS

CLUBS,
LOUNGES
+BARS

SOJU BAR

Skalitzer Straße 36 // Kreuzberg
Tel.: +49 (0)30 48 81 24 60
www.soju-bar.com

Wed–Sat from 11 pm

U1 Görlitzer Bahnhof

Prices: $$

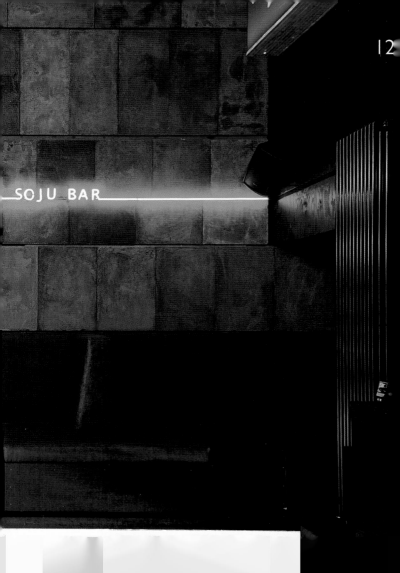

SOJU BAR

The little empire surrounding Kimchi Princess now includes a dance bar named after the sweet-potato liqueur you'll find everywhere in Korea. The Soju Bar takes you on an exquisite head trip: the hanging neon banners transplant you to the streets of Seoul. Wednesdays through Saturdays you'll have a great time listening to excellent party music—or doing karaoke. Kreuzberg in Korean.

Zu dem kleinen Imperium rund um Kimchi Princess gehört jetzt auch die Tanzbar, die nach dem in Korea omnipräsenten Süßkartoffelschnaps benannt ist. Es ist eine köstliche Kopfreise, auf die man sich in der Soju Bar begibt: Die herabhängenden Neonbanner versetzen einen direkt in die Straßen Seouls. Immer von Mittwoch bis Samstag kann man sich bei anspruchsvoller Partymusik – oder beim Karaoke – prächtig amüsieren. Kreuzberg auf Koreanisch.

Le petit empire de Kimchi Princess peut également se prévaloir de ce bar dansant portant le nom de la liqueur coréenne à base de patate douce. Une visite au Soju Bar vous fera voyager dans les rues de Séoul aux enseignes lumineuses. Du mercredi au samedi, vous pourrez vous danser sur de la musique rythmée ou chanter lors du karaoké. Vous expérimenterez ainsi la version coréenne de Kreuzberg.

El pequeño imperio de Kimchi Princess cuenta ahora también con el Soju, una sala de baile que toma su nombre del típico licor de batata coreano. Entrar en el Soju es como hacer unas divertidas vacaciones mentales. Los carteles de neón verticales nos transportan a las calles de Seúl. De miércoles a sábado se puede disfrutar de música de fiesta o de karaoke. Es, en definitiva, una interpretación del barrio Kreuzberg a la coreana.

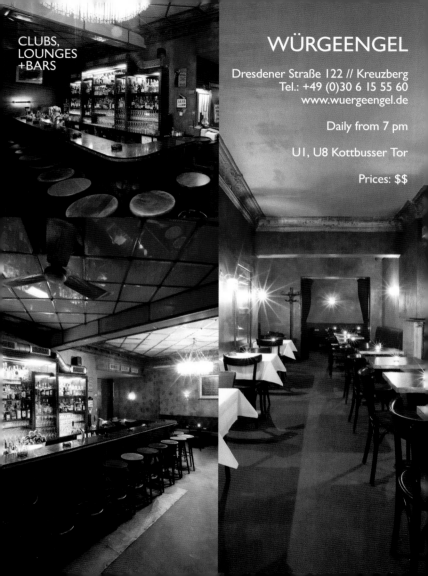

CLUBS,
LOUNGES
+BARS

WÜRGEENGEL

Dresdener Straße 122 // Kreuzberg
Tel.: +49 (0)30 6 15 55 60
www.wuergeengel.de

Daily from 7 pm

U1, U8 Kottbusser Tor

Prices: $$

Behind Kottbusser Tor you'll find that Würgeengel is the perfect blend of dignified bar and Kreuzberg pub. And just to be clear: the bar staff here is knowledgeable and friendly, not students working part-time. Regardless, you can rest assured that Würgeengel draws a diverse, fun-loving crowd. The reference to Buñuel's film "The Extermating Angel" could easily become a self-fulfilling prophecy: once you've entered, you'll find it hard to leave!

Hinter dem Kottbusser Tor liegt die perfekte Mischung aus gediegener Bar und Kreuzberger Kneipe. Nicht dass Missverständnisse aufkommen – hier arbeiten keine studentischen Aushilfskräfte, sondern fachkundiges und freundliches Barpersonal –, aber trotzdem ist der Würgeengel für ein breites, spaßorientiertes Publikum da. Die Buñuel-Referenz wird leicht zur selbst erfüllenden Prophezeiung: Einmal eingetreten, lässt einen die Bar so schnell nicht los.

Situé derrière le Kottbusser Tor, cet établissement allie ambiance distinguée et atmosphère décontractée typique du quartier de Kreuzberg. Que l'on ne s'y méprenne pas ; bien que le personnel du bar ne soit pas composé d'étudiants, mais de professionnels qualifiés de la gastronomie, l'Ange exterminateur accueille un public très hétéroclite. La prophétie de Luis Buñuel se perpétue : une fois entré, vous n'en ressortirez pas de sitôt.

La mezcla perfecta entre un bar de ambiente relajado y un pub al estilo Kreuzberg se puede hallar detrás del Kottbusser Tor. Para evitar malentendidos, aquí no trabajan estudiantes en sus horas ociosas, sino profesionales expertos y afables. No obstante, el Würgeengel, traducción alemana de la película "El Ángel exterminador" de Buñuel, se dirige a un público amplio con ganas de fiesta. La referencia al cineasta se convierte en una profecía ineludible. Este local acaba por atraparte.

CLUBS,
LOUNGES
+BARS

SPINDLER & KLATT

Köpenicker Straße 16 // Kreuzberg
Tel.: +49 (0)30 3 19 88 18 60
www.spindlerklatt.com

Thu–Sun from 8 pm
Fri–Sat from 11 pm

S3, S5, S7, S75 Ostbahnhof
U1 Schlesisches Tor

Prices: $$$

Winter in Berlin may seem Siberian, but summers can
have a true Mediterranean feel. There's something about
sitting on the huge terrace overlooking the Spree on a
warm night in July, drinking caipirinhas with good friends,
that makes you dream of Brazil. While lounge music
drifts out onto the terrace, inside guests dine on beds
and dance in this enormous former army bakery that
has been converted into a nightclub and restaurant.

Der Berliner Winter ist sibirisch hart, dafür können
die Sommer von südländischer Leichtigkeit sein. Sitzt
man also in einer lauen Julinacht gemütlich auf der riesigen
Terrasse direkt an der Spree und trinkt in guter Gesellschaft
Caipirinha, träumt man sich schnell nach Brasilien. Von
drinnen wabert Loungemusik nach draußen. In der zu einer
offenen Clubrestaurantlandschaft ausgebauten ehemaligen
Heeresbäckerei wird getanzt und auf Betten gespeist.

Les hivers berlinois font endurer un froid polaire mais
les étés peuvent offrir la légèreté des pays du sud. Assis
confortablement à une terrasse au bord du Spree durant
une douce nuit de juillet, tout en sirotant un Caipirinha
en bonne compagnie, on est transporté au Brésil. La
musique lounge de l'intérieur se diffuse langoureusement
sur la terrasse. Dans l'espace ouvert du club restaurant,
aménagé dans l'Heeresbäckerei, ancienne boulangerie
industrielle, on danse et on mange sur des lits.

Un frío siberiano envuelve la ciudad de Berlín en invierno.
Para compensar, los veranos pueden llegar a resultar
casi mediterráneos. En una noche calurosa, sentado en
esta terraza a orillas del río Spree y disfrutando de un
caipiriña en buena compañía, uno fácilmente se siente
transportado a Brasil. Desde dentro emana una vibrante
música lounge. En esta antigua planta panificadora
convertida en club-restaurante se puede bailar o comer
sobre unas enormes tarimas en forma de cama.

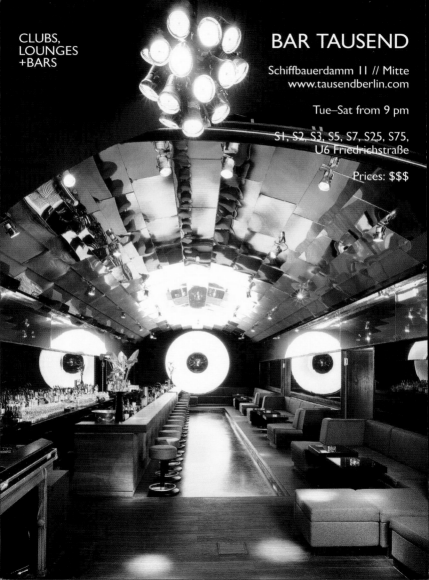

CLUBS,
LOUNGES
+BARS

BAR TAUSEND

Schiffbauerdamm 11 // Mitte
www.tausendberlin.com

Tue–Sat from 9 pm

S1, S2, S3, S5, S7, S25, S75,
U6 Friedrichstraße

Prices: $$$

This bar is deliberately hard to find, and from the outside you'd never guess that there's a simple yet luxurious world within. If you can even get in, that is. As is often the case in Berlin, cool doesn't automatically mean casual, and definitely not cheap. With the long bar and magical lighting as a backdrop, this place quickly fills with beautiful, stylish people. The music here is a good mix, almost always live, and always first class.

Die Bar ist schwer zu finden, und das ist auch so beabsichtigt. Nichts weist von außen auf den luxuriösen und doch schlichten Kosmos hin, der den Gast drinnen erwartet. Wenn er Einlass findet. Denn hier ist, wie sonst sehr oft in Berlin, cool nicht gleich lässig oder gar ranzig. Schöne, stilsichere Menschen füllen die Kulisse mit der langen Bar und dem magischen Lichtkreis. Die Musik ist fast immer live, immer erstklassig und abwechslungsreich.

TITA VON HARDENBERG'S SPECIAL TIP

One of very few places where you can dance AND talk. Also, the interior design is always a feast for the eyes.

Ce bar n'est pas facile à trouver et ce n'est pas par hasard. Rien ne laisse présager au client qui arrive devant l'entrée un univers luxueux et sobre à la fois. S'il a la chance d'y être admis. Car comme partout à Berlin, « cool » ne rime pas avec nonchalant, ni délabré. On y trouve plutôt une clientèle distinguée qui se prélasse au bar, au cœur d'un halo magique. La musique y est toujours « live », orchestrée par différents groupes de première classe.

El bar es difícil de encontrar y esa es precisamente la intención. Desde fuera nada delata el lujoso y, sin embargo, sencillo cosmos que espera al huésped en el interior. Si llega a entrar. Porque aquí lo cool no es, como sucede a menudo en Berlín, desenfadado o incluso rancio. El local, con su larga barra y el mágico círculo de luz, está lleno de personas guapas y con estilo. La música suele ser en directo, siempre de primera clase y muy variada.

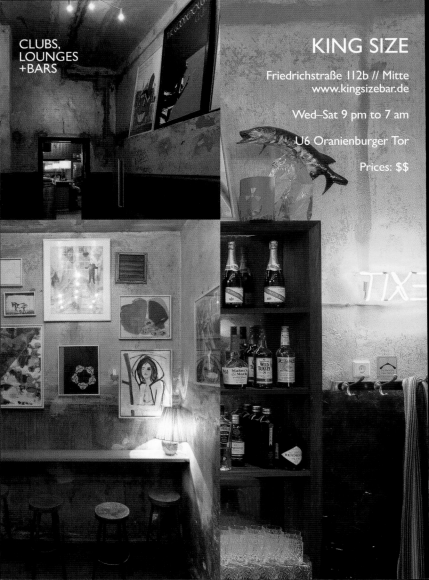

CLUBS,
LOUNGES
+BARS

KING SIZE

Friedrichstraße 112b // Mitte
www.kingsizebar.de

Wed–Sat 9 pm to 7 am

U6 Oranienburger Tor

Prices: $$

Let's make this clear up front: this bar is tiny and everybody wants in. On the weekends in particular it feels like King Size is the last lifeboat before the great flood. Opened by Boris Radczun, Stephan Landwehr (Grill Royal), and "party king" Conny Opper in a rundown space, this bar is a bright light to many in the Mitte district and a place where you'll see an older party generation come to life again.

Um es vorweg zu sagen: Die Bar ist winzig, und alle wollen rein. Vor allem am Wochenende bekommt man das Gefühl, das King Size sei das letzte Rettungsboot. Danach die Sintflut. Und tatsächlich gibt die von Boris Radczun, Stephan Landwehr (Grill Royal) und dem sogenannten „Partykönig" Conny Opper in einem runtergekommenen Raum platzierte Bar vielen Menschen in Mitte Hoffnung. Hier flackert das Licht einer älteren Feiergeneration noch mal auf.

TITA VON HARDENBERG'S SPECIAL TIP

Once you've ventured into the narrow passage, finding your way out isn't so easy. Generous drinks and the best music.

Autant que vous le sachiez de suite, ce bar est minuscule, et tout le monde veut y entrer. Le week-end, on a l'impression que c'est le dernier bateau de sauvetage avant le déluge. Pourtant, les clients ne perdent pas espoir de pouvoir pénétrer dans ce bar, situé dans une salle délabrée du centre de Berlin, et tenu par une équipe de choc : Boris Radczun, Stephan Landwehr (Grill Royal) et Conny Opper, le « Roi de la fête à Berlin ». La flamme de l'ancienne génération des fêtards retrouve ici tout son éclat.

De entrada cabe decir que el bar es diminuto y que todos quieren entrar. Sobre todo los fines de semana, cuando el King Size parece ser el último bote salvavidas en pleno diluvio universal. De hecho, el local que Boris Radczun, Stephan Landwehr (Grill Royal) y Conny Opper, el "Rey de la rumba", montaron en una habitación desvencijada del barrio Mitte, ha sido una inyección de esperanza para muchos. Aquí vuelve a arder la antorcha de una generación de festeros de antaño.

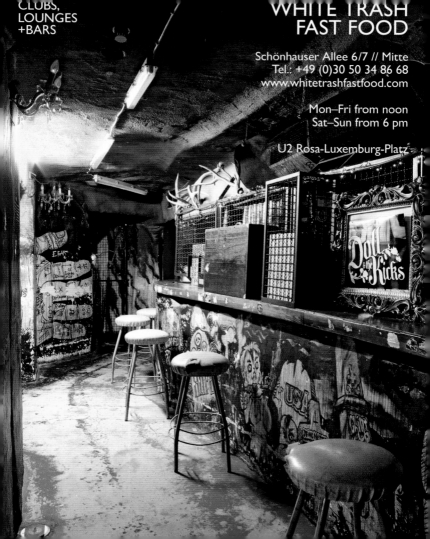

In this former Irish Pub with an ambience somewhere between a Chinese restaurant and a saloon, you can nurse your hangover with a tasty hamburger or maybe just tie one on in the first place. Here you'll find a Berlin that is more rock 'n' roll than electro, a place where you can get a tattoo or watch a movie in the smoking cinema. This isn't just a marketing idea; it began ten years ago in an artist's kitchen and apparently got a bit out of hand.

In dem ehemaligen Irish Pub mit seinem Interieur irgendwo zwischen Chinarestaurant und Saloon kann man bei einem schmackhaften Burger seinen Kater auskurieren. Oder sich erst mal richtig einen holen. Denn hier ist Berlin nicht elektrolastig, sondern Rock 'n' Roll. Vor Ort wird auch tätowiert, und es gibt ein Raucherkino. Das Ganze ist keine Marketingidee, sondern begann vor zehn Jahren in einer Künstlerküche und geriet wohl etwas außer Kontrolle.

Cet ancien pub irlandais, à l'intérieur alliant décor chinois et ambiance saloon, est le lieu parfait pour venir à bout de sa gueule de bois en dégustant un excellent burger, ou pour se prendre une bonne cuite. Ici, c'est plutôt le Berlin Rock 'n' Roll qu'électro. Vous pouvez vous y faire tatouer et profiter du cinéma fumeur. Cet ensemble ne repose pas sur une idée marketing, il a vu le jour il y a une dizaine d'années dans une cuisine d'artistes et a fini par déraper légèrement.

En este antiguo pub irlandés, cuyos interiores oscilan entre los de un restaurante chino y un bar del salvaje oeste, el comensal puede reponerse de la última resaca con una sabrosa hamburguesa; o continuar con las copas. Lejos de la música electrónica, la ciudad revela aquí su cara más Rock. Hay un estudio de tatuaje y cine para fumadores. El concepto no surgió en base a una estrategia de marketing. Todo empezó hace diez años con una cocina de artistas que, entretanto, ha adquirido una dinámica propia.

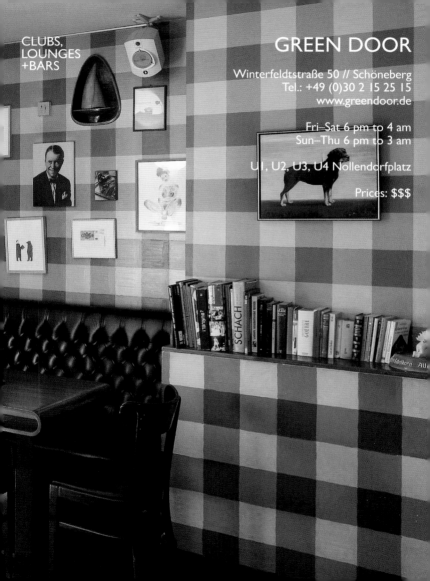

CLUBS,
LOUNGES
+BARS

GREEN DOOR

Winterfeldtstraße 50 // Schöneberg
Tel.: +49 (0)30 2 15 25 15
www.greendoor.de

Fri–Sat 6 pm to 4 am
Sun–Thu 6 pm to 3 am

U1, U2, U3, U4 Nollendorfplatz

Prices: $$$

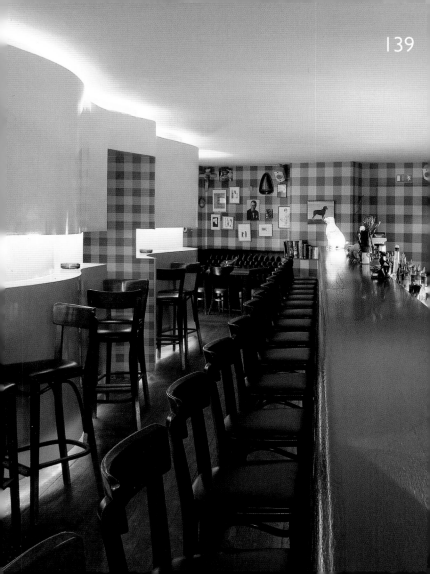

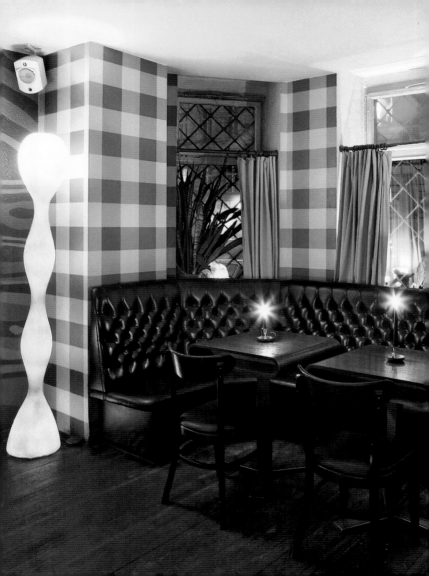

What secrets lurk behind the green door? During American Prohibition, green doors marked a speakeasy where people could find illegal booze. There is a similar but different association with "Behind the Green Door," the 1972 porn classic. Yet if you ring the doorbell and gain entrance, you'll find yourself in a bar with both character and culture. Fritz Müller-Scherz and his team provide hospitality in this bar which is dedicated to jazz guitarist Eddie Condon.

Welches Geheimnis verbirgt sich hinter der grünen Tür? Grüne Türen waren im Amerika der Prohibition ein Marker für illegalen feuchten Spaß. Ähnlich, aber anders, die Assoziation mit „Behind the Green Door", dem Pornofilmklassiker von 1972. Wer klingelt und Einlass findet, landet hier jedenfalls in einer Bar mit Charakter und Kultur. Pate ist der Jazzguitarist Eddie Condon, verantwortlich für die Gastfreundschaft sind indes Fritz Müller-Scherz und sein Barteam.

Quel secret dissimule cette porte verte ? À l'époque de la prohibition en Amérique, les portes vertes étaient l'emblème des établissements où l'on consommait illégalement de l'alcool. Ce nom rappelle également le classique du film érotique de 1972, « Behind the Green Door ». Pour y entrer, il faut sonner, vous découvrirez ensuite un bar original et culturel. Le guitariste de Jazz, Eddie Condon, parrain des lieux ainsi que Fritz Müller-Scherz et son équipe vous feront passer un agréable moment.

¿Qué tipo de secreto guarda la puerta verde? En tiempos de la Ley Seca, las puertas de color aceituna señalizaban la venta de líquidos ilegales para levantar el ánimo. Este término también podría asociarse a un clásico del porno de 1972, "Behind the Green Door". Aquel que llame a la puerta y sea admitido hallará un bar con carácter y cultura. Eddie Condon, guitarrista de jazz, es el padrino del local. Fritz Müller-Scherz y su equipo tras la barra reciben y miman a los clientes.

CLUBS,
LOUNGES
+BARS

VICTORIA BAR

Potsdamer Straße 102 // Tiergarten
Tel.: +49 (0)30 25 75 99 77
www.victoriabar.de

Fri–Sat 6:30 pm to 4 am
Sun–Thu 6:30 pm to 3 am

U1 Kurfürstenstraße

Prices: $$$

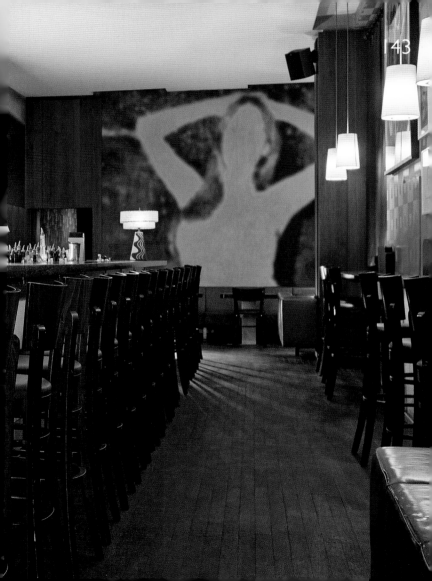

Okay, Potsdamer Straße can be a turn-off. But then you come to this cultivated locale, a classic barroom with understated dark furnishings and a lovely bar. Head bartender Stefan Weber, considered by many to be the best barkeeper in Berlin, can take you to the "school of inebriation" and impart deep knowledge of high-quality spirits. And a world-class chef will satisfy your hunger. Mixology is taken seriously here—and with a sense of humor.

Gut, die Potsdamer Straße kann abschrecken. Dann aber betritt man diesen kultivierten Ort, eine klassische Bar mit dezenter, dunkler Einrichtung und edler Theke. Bei Barchef Stefan Weber, der vielen als bester Barkeeper Berlins gilt, kann man in die „Schule der Trunkenheit" gehen und sich tiefes Wissen über hochwertige Alkoholika aneignen. Und ein Spitzenkoch stillt den Hunger. Hier wird Trinkkultur ernst genommen, mit Humor.

TITA VON HARDENBERG'S SPECIAL TIP

The place for lovers of perfectly mixed cocktails. The interior is tasteful, and you can converse undisturbed.

La Potsdamer Straße pourrait en dissuader plus d'un. Mais lorsque l'on pénètre dans ce lieu cultivé, un bar classique au décor délicat et sombre avec un beau comptoir, la surprise n'en est que plus belle. Chez Stefan Weber, considéré par bon nombre comme le meilleur tenancier de bar de tout Berlin, vous découvrirez « L'école de l'Ivresse » où vous pourrez apprendre les secrets de différents alcools de qualité. Un grand chef y assouvira votre faim. La culture de la boisson est ici prise au sérieux, mais avec humour.

Vale, la Potsdamer Straße puede dar susto. Por lo menos, hasta que uno entra en este lugar distinguido; un bar clásico con una decoración discreta y tenue. Stefan Weber, jefe de la elegante barra y para muchos mejor barman de la ciudad, inicia al cliente en "el arte de la embriaguez" y le transfiere sus profundos conocimientos sobre el alcohol. Mientras, un chef estrella vela por saciar los apetitos. Aquí, la cultura de la copa es tomada en serio, pero con humor.

HIGHLIGHTS

COOL
BERLIN

So much has changed in the production of neckties—except, of course, for the quality of the exquisite silks used in these hand-made ties, scarves, bow ties, and dressing gowns. Also unchanged is the unflagging dedication shown by the employees in the decades that they've pursued their craft. Bold spirit that he is, young Mr. Scheper-Stuke is a true dandy who is breathing elegant new life into this venerable century-old company.

Nichts ist in der Krawattenmanufaktur mehr so, wie es einmal war. Außer natürlich die Qualität der edlen Seidenstoffe, aus denen Krawatten, Schals, Schleifen und Morgenmäntel von Hand gefertigt werden. Und die Hingabe, mit der die Mitarbeiterinnen seit Jahrzehnten ihrem Handwerk nachgehen. Andererseits haucht der junge Herr Scheper-Stuke, ein kühner Geist und wahrer Dandy, dem 100-jährigen Traditionsunternehmen sehr elegant neues Leben ein.

Rien n'est plus comme avant dans cette manufacture de cravates, si ce n'est la qualité de la soie avec laquelle sont confectionnées à la main les cravates, nœuds papillons, foulards et robes de chambre. Depuis des siècles, la passion à l'ouvrage dont font preuve les employées d'Edsor Kronen n'a pas changé non plus. De plus, le jeune M. Scheper-Stuke, un vrai dandy qui ne manque pas d'audace, insuffle un vent nouveau à cette entreprise traditionnelle vieille de 100 ans.

Todo ha cambiado en la manufactura de corbatas. Salvo, por supuesto, la excepcional calidad de los tejidos de seda a partir de los cuales se elaboran a mano corbatas, bufandas, pajaritas y albornoces. También sigue presente la enorme dedicación con la que los empleados ejercen su oficio desde hace décadas. El Sr. Scheper-Stuke, joven propietario y todo un dandi conocido por sus planteamientos atrevidos, insufla aires innovadores a esta casa de larga tradición de 100 años de antigüedad.

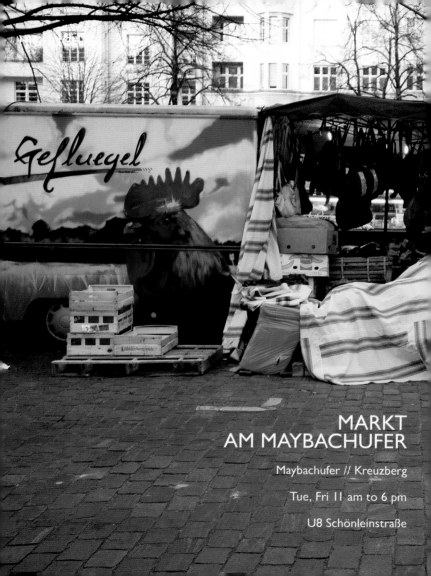

MARKT
AM MAYBACHUFER

Maybachufer // Kreuzberg

Tue, Fri 11 am to 6 pm

U8 Schönleinstraße

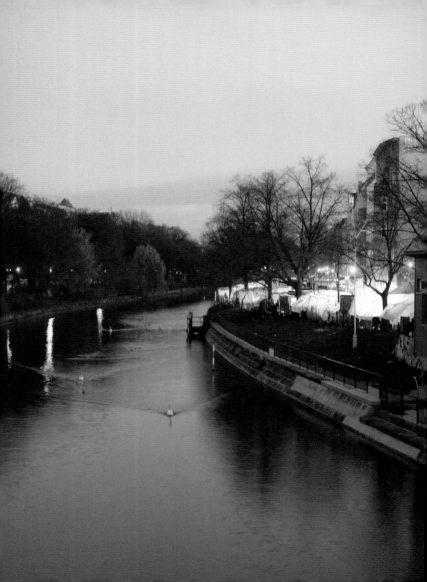

Hoşgeldiniz and welcome to Little Istanbul! Each Tuesday and Friday, Maybachufer is transformed into an open-air bazaar where everything from vegetables to meat and fish to housewares and fabrics is available for purchase. Haggling is permitted, and just before closing time you can get some good deals. It's liveliest and the most pleasant in the summer when Kreuzberg's hippies play music and carry on at the far end.

Hoşgeldiniz und herzlich willkommen in Little Istanbul! Jeden Dienstag und Freitag verwandelt sich das Maybachufer in einen Freiluftbazar, wo es von Gemüse über Fleisch und Fisch bis zu Haushaltswaren und Stoffen alles zu kaufen gibt. Handeln ist erlaubt, und besonders kurz vor Schluss kann man gute Schnäppchen machen. Im Sommer ist es am schönsten und lebendigsten. Dann tummeln sich am hinteren Ende die Kreuzberger Hippies und machen Musik.

Hoşgeldiniz et bienvenue dans le petit Istanbul ! Le Maybachufer se transforme tous les mardis et vendredis en un grand bazar en plein air, où vous pouvez acheter légumes, viande, poisson, articles ménagers, tissus et autres. Le marchandage y est permis et les meilleures affaires se font peu avant la fermeture. La saison la plus agréable pour profiter de ce marché est l'été, lorsque les hippies du Kreuzberg viennent y folâtrer et faire de la musique derrière la dernière échoppe.

¡Hoşgeldiniz y bienvenidos a la pequeña Estambul! Los martes y viernes, las orillas del Maybachufer se convierten en un bazar al aire libre donde uno encuentra de todo, desde verdura, carne, pescado y electrodomésticos, hasta productos textiles. Se permite regatear y, justo antes del cierre, pueden conseguirse auténticas gangas. En verano, el mercado muestra su cara más viva y atractiva. Entonces, los hippies del barrio Kreuzberg se reúnen aquí para inventar nuevos ritmos.

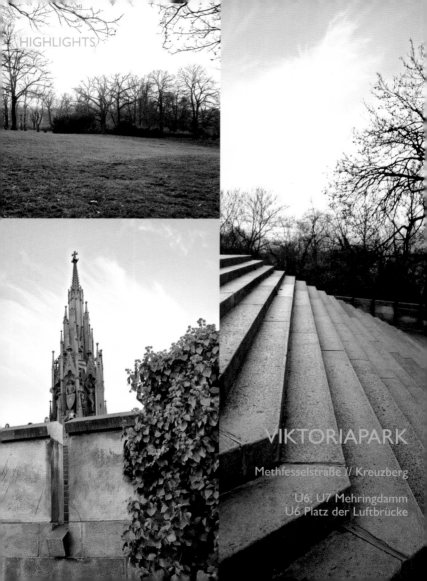

HIGHLIGHTS

VIKTORIAPARK

Methfesselstraße // Kreuzberg

U6, U7 Mehringdamm
U6 Platz der Luftbrücke

Who would guess that Berlin's (in)famous district is named after a mountain? At 216 feet, "Mount" Kreuzberg in the middle of Viktoriapark is the highest point in Berlin. After a short climb up to the liberty monument, you can look out over the artificial waterfall (which looks remarkably natural) and the city. The park also includes a small vineyard that produces the local Kreuz-Neroberger wine—though, unfortunately, it is not available anywhere.

Wer hätte geglaubt, dass der berühmt-berüchtigte Bezirk nach einem Berg benannt ist? Es ist, logischerweise, der Kreuzberg, mit 66 Metern die höchste natürliche Erhebung der Stadt, im Zentrum des Viktoriaparks. Nach kurzem Aufstieg genießt man vom Freiheitsdenkmal aus die Sicht auf den zwar angelegten, aber natürlich wirkenden Wasserfall und die Stadt. Malerisch ist auch, dass hier Wein angebaut wird, der (leider) nirgendwo erhältliche Kreuz-Neroberger.

Qui aurait cru que ce quartier mal réputé portait le nom d'une montagne ? Il s'agit naturellement de Kreuzberg qui, du haut de ses 66 mètres, est la colline naturelle la plus élevée de la ville, au cœur du Viktoriapark. Après une petite montée jusqu'au Freiheitsdenkmal (mémorial à la liberté), vous pourrez profiter d'une superbe vue sur la cascade artificielle et la capitale. Autre côté pittoresque : les vignes dont est issu le Kreuz-Neroberger, que l'on ne peut (malheureusement) se procurer nulle part.

¿Quién habría creído que tan notorio barrio iba a portar el nombre de un monte? Hablamos, por supuesto, de Kreuzberg, ubicado en el parque de Viktoriapark. Con sus 66 metros de altura, este montículo constituye la mayor elevación natural de la urbe. Desde el monumento a la libertad se abre una vista panorámica de la cascada artificial y la ciudad. También resulta pintoresco que aquí arriba se cultiven vides para realizar un vino —el Kreuz-Neroberger— que, (por desgracia), no se comercializa.

BUCHSTABENMUSEUM

Karl-Liebknecht-Straße 13,
Berlin Carré, 2nd floor // Mitte
Tel.: +49 (0)177 4 20 15 87
www.buchstabenmuseum.de

Thu–Sat 1 pm to 3 pm

S3, S5, S7, S75,
U2, U5, U8 Alexanderplatz

Still without a permanent home, this collection is literally unique. This museum of letters is not just for graphic design nerds and typography enthusiasts. Above all else, these "rescued" characters and logos are artifacts of their times and art objects with historical and emotional value. Each exhibit has a documented history of its origin. While these objects are currently from around Berlin, in the future letters will arrive from all over the world.

Buchstäblich einzigartig ist diese Sammlung, die noch eine feste Heimat sucht. Ein Besuch sei nicht nur Grafik-Nerds und Typografiebegeisterten empfohlen. Denn die „geretteten" Zeichen und Schriftzüge sind vor allem Zeitzeugen und Kunstobjekte mit historischem und emotionalem Wert. Jedes Exponat hat eine dokumentierte Entstehungsgeschichte. Noch sind es Geschichten aus der Region Berlin – in Zukunft werden Buchstaben aus der ganzen Welt anreisen.

Cette collection, littéralement unique, cherche encore un refuge sûr. Elle n'est pas réservée aux amateurs de graphique ou de typographie car les lettres et autres inscriptions « sauvées » sont des témoins de l'histoire et des œuvres d'art manifestant une valeur émotionnelle. L'origine de chaque pièce exposée est documentée historiquement. Pour le moment, les lettres exposées proviennent essentiellement de Berlin mais bientôt elles viendront du monde entier.

Esta colección, todavía en busca de una sala fija de exposiciones, es literalmente única. Su visita no sólo se recomienda a los fanáticos del mundo gráfico o a los aficionados de la tipografía. Las letras y caligrafías "salvadas" son, ante todo, testigos de una época y objetos de arte con un gran valor histórico y emocional. Cada objeto cuenta la historia de su procedencia. Aún son solamente obras de la región de Berlín, pero en el futuro se añadirán letras de todo el mundo.

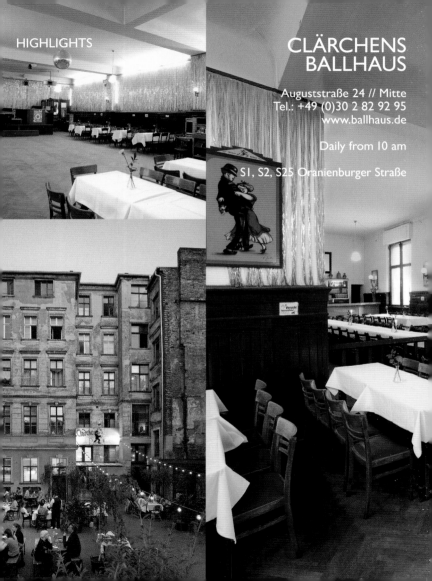

CLÄRCHENS
BALLHAUS

Auguststraße 24 // Mitte
Tel.: +49 (0)30 2 82 92 95
www.ballhaus.de

Daily from 10 am

S1, S2, S25 Oranienburger Straße

Named after Clara, the wife of its founder, this unique ballroom in Berlin has been drawing dancers for a century. People of all ages move to the rhythms of swing, salsa, tango, and ballroom numbers. You can drop in for the classic tea dance on Sundays or check out the dance courses held several evenings a week. But nobody is forced onto the dance floor—you're welcome to simply relax and enjoy this historic room over a burger and potato salad.

Seit einem Jahrhundert zieht das einzige derart erhaltene Ballhaus Berlins, benannt nach Clara, der Frau des Gründers, Tänzer an. Zu Swing, Salsa, Tango und Standardtanz wiegen sich Menschen verschiedensten Alters im Takt. Sonntags gibt es ganz klassisch Tanztee und an mehreren Abenden in der Woche Tanzkurse. Aber keiner muss aufs Parkett – man kann sich im historischen Saal auch beim Verzehr einer Bulette mit Kartoffelsalat vergnügen.

Cette salle de bal berlinoise unique en son genre, portant le nom de Clara, la femme de son fondateur, attire des passionnés de danse depuis un siècle. Pour danser le swing, la salsa, le tango ou autres danses classiques, des danseurs de tous âges se laissent aller en cadence. Chaque dimanche, thé dansant au programme et pendant la semaine, cours du soir. Mais personne n'est obligé de danser, on peut s'y rendre juste pour déguster une boulette de viande avec salade de pommes de terre.

Este único salón de baile berlinés, conservado con todo su encanto, sigue atrayendo al público desde hace más de un siglo. Con el nombre de Clara —la esposa del fundador— el local aúna a personas de todas las edades que se mueven a ritmo de swing, salsa, tango y estándar. Los domingos se organiza un té con baile y durante la semana se ofrecen varios cursos de baile. Salir a la pista no es obligatorio, también se puede disfrutar de unas albóndigas y una ensalada de patata en la histórica sala.

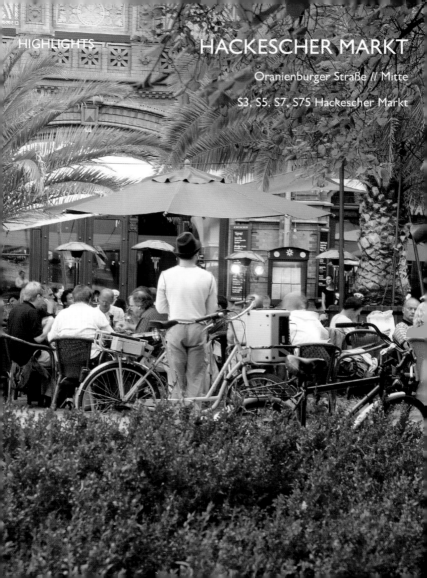

HACKESCHER MARKT

Oranienburger Straße // Mitte

S3, S5, S7, S75 Hackescher Markt

Because it's such a huge tourist site, many people fail to appreciate the beauty and significance of the Hackesche Höfe complex. These unique courtyards and their history are well worth a second look. Two world wars had a huge impact on the flourishing cultural life here. Confiscated, repurposed, and neglected after 1945, they were restored to new glory in the mid 1990s thanks in large part to their tenants and a great deal of initiative.

Weil sie eine riesige Touristenschleuse sind, werden die Hackeschen Höfe in ihrer Bedeutung und Schönheit oft verkannt. Diese einzigartigen Gewerbehöfe und ihre Geschichte sollte man sich genauer ansehen. Zwei Weltkriege durchkreuzten das kulturell florierende Leben in den Höfen. Nach 1945 enteignet, zweckentfremdet und vernachlässigt, erstrahlten sie, nicht zuletzt dank ihrer Mieter und viel Eigeninitiative, Mitte der 90er-Jahre in neuem Glanz.

Site peu touristique, son importance et sa beauté restent souvent méconnues. Cet ensemble de cours intérieures et leur histoire valent pourtant le déplacement. La vie culturelle florissante y fut ralentie par les deux guerres mondiales. Après avoir perdu leurs propriétaires respectifs, été détournées de leur destination première et laissées à l'abandon après 1945, les cours ont retrouvé leur éclat au milieu des années 90 grâce au dynamisme des nouveaux locataires.

Incontables turistas pasan por el conjunto urbanístico Hackesche Höfe a diario, pero muy pocos reparan en la belleza e importancia de esta construcción. Desde luego, vale la pena fijarse en la historia y peculiaridad del centro comercial. Su rica vida cultural estuvo marcada por dos guerras mundiales y, tras 1945, fue descuidado y alejado de su verdadera función. Gracias al compromiso de los inquilinos y la dedicación de algunos volvió a adquirir su antiguo esplendor a partir de los años 90.

 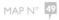

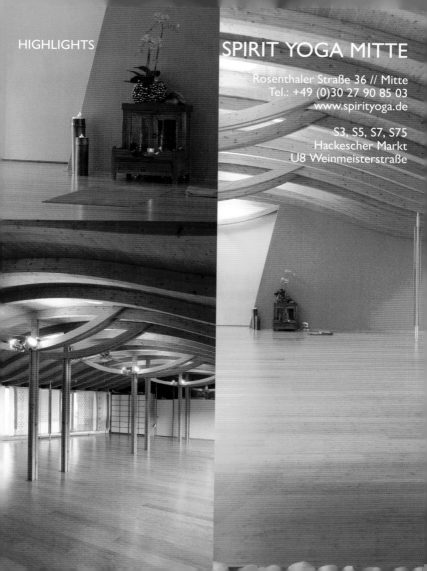

SPIRIT YOGA MITTE

Rosenthaler Straße 36 // Mitte
Tel.: +49 (0)30 27 90 85 03
www.spirityoga.de

S3, S5, S7, S75
Hackescher Markt
U8 Weinmeisterstraße

To get a true feel for yoga, you need to try it for yourself and see what it might offer you. Among the many studios in Berlin, Patricia Thielemann's Spirit Yoga is a real find, both in terms of its approach and its interior. At the Mitte studio, students are given expert instruction under a beautifully curved wooden roof. At Charlottenburg, you can follow up with a sauna and a massage. What a perfect way to relax, even for travelers passing through.

Jeder muss selbst herausfinden, ob Yoga einem etwas gibt und was das ist. Unter den vielen Studios in Berlin ist Patricia Thielemanns Spirit Yoga in seiner Ausrichtung und Einrichtung eine Perle. In Mitte übt man unter einem wunderschön geschwungenen Holzdach und fachkundiger Anleitung. In der Charlottenburger Filiale kann man hinterher noch in die Sauna gehen und sich massieren lassen. Auch für Durchreisende die perfekte Art zu entspannen.

À chacun de découvrir ce qu'est le yoga et s'il peut lui faire du bien. Parmi la multitude de studios à Berlin, celui de Patricia Thielemann est un véritable paradis où l'énergie positive et le décor vous envoûtent. Situé au cœur de la capitale, dans une salle arborant un plafond de bois aux lignes courbes, vous pourrez libérer vos chakras en vous laissant guider par une experte. Le studio du Charlottenburg propose aussi des séances de sauna et de massage. Une étape parfaite aussi pour les voyageurs désireux de détente.

Cada uno debe descubrir por sí mismo si el yoga le llena y hasta qué punto. Entre los muchos estudios en Berlín, los centros de Patricia Thielemann destacan por su planteamiento y su equipamiento. En el barrio Mitte uno se puede ejercitar en compañía de un monitor cualificado bajo un imponente techo ondulado de madera. En la filial del distrito de Charlottenburg la oferta incluye además una sauna y masajes. Un lugar idóneo para relajarse incluso para aquellos que sólo están de paso.

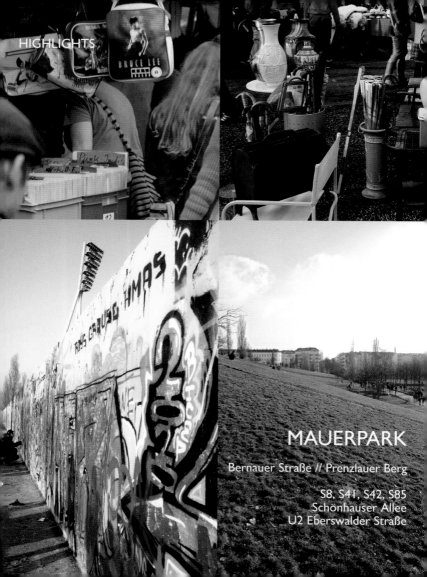

HIGHLIGHTS

MAUERPARK

Bernauer Straße // Prenzlauer Berg

S8, S41, S42, S85
Schönhauser Allee
U2 Eberswalder Straße

The former border strip at Bernauer Straße has grown into a much-loved park among hipsters and hippies. It might not be the most beautiful park but it is one of the liveliest, and it has a lot to offer. The flea market draws unbelievable crowds on Sundays, and afterwards you can listen to musicians and drummers or do traditional karaoke. If you've got the nerve, that is: hundreds of people show up every week.

Der ehemalige Grenzstreifen an der Bernauer Straße ist zu einem von Hipstern wie von Hippies heiß geliebten Park gewachsen. Er ist vielleicht nicht der Schönste, aber er ist einer der Lebendigsten, und er hat sehr viel zu bieten. Jeden Sonntag zieht der Flohmarkt unglaubliche Menschenmassen an. Danach kann man Musikern und Trommlern lauschen oder am traditionellen Karaoke teilnehmen. Wenn man sich traut: Hunderte wohnen diesem Spektakel bei.

TITA VON HARDENBERG'S
SPECIAL TIP

Grown-ups on swings, fire breathers, karaoke talent, and perpetual drummers. The slightly offbeat kind of urban recreation. Always worthwhile.

L'ancienne frontière de la Bernauer Straße est devenu un parc où les bobos et hippies aiment se promener. Ce n'est peut-être pas le plus beau, mais bien le plus animé de la ville. Tous les dimanches, le marché aux puces attire les foules. Les musiciens et les joueurs de tambours vous enivrent de leurs mélodies. Si vous êtes audacieux, vous pourrez participer au karaoké traditionnel, où des centaines de personnes viendront vous écouter.

La antigua franja fronteriza de la Bernauer Straße se ha convertido en el parque favorito tanto de los más modernos, como de los más hippies. Quizás no sea el más bonito, pero sin lugar a dudas es uno de los lugares con más vida de la ciudad y tiene mucho que ofrecer. Cada domingo, el rastro atrae a un sinfín de personas. Después, uno puede escuchar a los músicos, sumergirse en una batucada o participar en el ya tradicional karaoke. Aquel que se anime tendrá cientos de espectadores.

TEMPELHOF

Columbiadamm 2 // Tempelhof
www.flughafen-berlin-tempelhof.com

Check website for guided tours

U6 Platz der Luftbrücke

Restaurant

The only things taking off at Tempelhof airfield these days are kites. The enormous outside space has been a public park since 2008. Hard to imagine that in the days of the Airlift, when the so-called candy bombers supplied West Berlin, planes were taking off and landing here every 90 seconds. You can take a guided tour of the imposing complex of buildings—a reference to Nazi architecture—or see them while attending the Bread & Butter fashion show.

Heute steigen in Tempelhof nur noch Drachen in die Lüfte. Das riesige Außenareal ist seit 2008 ein öffentlich zugänglicher Park. Nicht auszudenken, dass hier in der Zeit der Luftbrücke, als die sogenannten „Rosinenbomber" Westberlin versorgten, Flugzeuge im 90-Sekundentakt starteten und landeten. Den imposanten Gebäudekomplex – eine Referenz an die NS-Architektur – kann man bei einer Führung besichtigen. Oder als Besucher der Modemesse Bread & Butter.

De nos jours, le ciel de Tempelhof n'est parcouru que par des cerfs-volants. Cet ancien aéroport, où pendant la période du pont aérien, les avions américains de ravitaillement de Berlin Ouest décollaient et atterrissaient toutes les 90 secondes, est un parc rendu public depuis 2008. Vous pouvez visiter l'impressionnant complexe rappelant l'architecture nazie avec un guide ou en tant que visiteur du salon de la mode Bread & Butter.

Hoy, sólo las cometas se alzan en Tempelhof. El enorme terreno fue reconvertido en parque público en 2008. Es curioso pensar que en tiempos del puente aéreo, cuando los Rosinenbomber de los aliados abastecían de comida y medicinas a la población de Berlín-Oeste, los aviones iban y venían cada 90 segundos. Hay visitas guiadas para ver el imponente conjunto urbanístico, claro ejemplo de la arquitectura nacionalsocialista. Las instalaciones también albergan el festival de moda Bread & Butter.

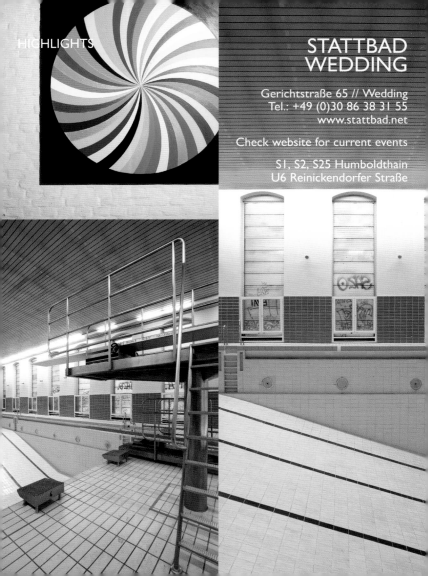

At some point this showpiece of Prussian architecture in the "wild" district of Wedding was overtaken by time. Damaged during World War II and remodeled in the fifties and sixties, the pool facility was finally abandoned in 2001. Then recently it was turned into a unique—waterless—platform for (urban) art and culture. The operators are justifiably proud that the pool is not misused as just another cool party location, but provides space and time for contemporary creative ideas.

Irgendwann wurde das im „wilden Wedding" gelegene preußische Prunkstück von der Zeit überholt. Nach Kriegs-verletzung und Umbau in den 50ern und 60ern gab man die Badeanstalt 2001 auf. Bis sie – wasserlos – jüngst als einzigartige Plattform für (urbane) Kunst und Kultur wieder auftauchte. Die Betreiber sind mit Recht stolz darauf, dass das Bad nicht als x-te coole „Partylocation" missbraucht wird, sondern kreativen Ideen Raum und Zeit bietet.

Ce fleuron de l'ère prussienne, situé dans le quartier populaire de Wedding, a passé toutes les époques. Suite à des dégâts causés par la guerre, cet établissement de bains a été rénové dans les années 50/60, ensuite abandonné en 2001, pour devenir depuis peu une plateforme unique – vidée de son eau – de la culture et l'art urbain. Les gérants sont fiers d'avoir pu éviter que ce joyau de l'histoire ne devienne l'énième « lieu de soirée » tendance de la capitale et de l'avoir transformé en un lieu voué à l'art contemporain et la création.

En algún momento, a la joya arquitectónica prusiana ubicada en el "agreste" barrio de Wedding le llegó su hora. Tras sufrir varias heridas de guerra y una rehabilitación en los años 50/60, la piscina cerró en 2001. Hace poco, se transformó en una plataforma única para el arte y la cultura (urbanos). Sus gestores se enorgullecen mereci-damente de que el antiguo baño público, ya sin gota, no haya acabado como enésima sala vanguardista de fiestas, sino que acoja hoy las ideas creativas de nuestro tiempo.

PRENZLAUER BERG

It seems hard to imagine the subversive, run-down times of this district. Today most buildings are neatly renovated and inhabited by international academics and young families with children. Strolling along Kastanienallee (also dubbed "Casting allee") you encounter a fashion and trend conscious crowd. The sheer number of cafés and shops is overwhelming.

MITTE

The post-Wall heart of the city links Berlin's history-charged past with its hip future. Edgy art galleries and sophisticated museums, state-of-the-art boutiques and old trade, the socialist dream of urban design and historic landmarks—and everything within walking distance. Lean back and watch tourists, politicians, hipsters, and artsy people mingle.

FRIEDRICHSHAIN/KREUZBERG/NEUKÖLLN

While people in Mitte still pretend to be working on "projects," in Kreuzberg you can chill out in parks, by the canal, or in cool cafés all day, then later eat great food in a laid-back atmosphere, and afterwards you can proceed to a bar without feeling guilty at all. Half rebellious, half bourgeois, and very Turkish: here anything goes. Its neighboring district Neukölln is similar and almost as popular—at least the northern part, where Little Istanbul is a popular shopping spot—and you see new bars popping up every day. Friedrichshain lacks that oriental flair. The former east district does, however, house the best (and most notorious) clubs—and an intriguing mix of party people, punks, students, and alternative families.

TIERGARTEN/SCHÖNEBERG/CHARLOTTENBURG

This is where things were happening before the Wall came down. These days you'll find all the popular hot spots further to the east, but this was the place to be in times past—during the Golden Twenties or in the psychedelic Seventies, for example. These distinguished districts have grown old, not boring. Charlottenburg is the most refined, offering jazz venues, upscale shopping and restaurants, art, and even a castle. Friendly Schöneberg is home to a big gay community and people seeking a high quality of life. Tiergarten, with the hyper-modern Potsdamer Platz and the newly built governmental district by the Spree has been the area physically most affected by reunification. Its huge green lung, the Tiergarten park, is a beautiful place to leave the city behind.

COOL **MAP**

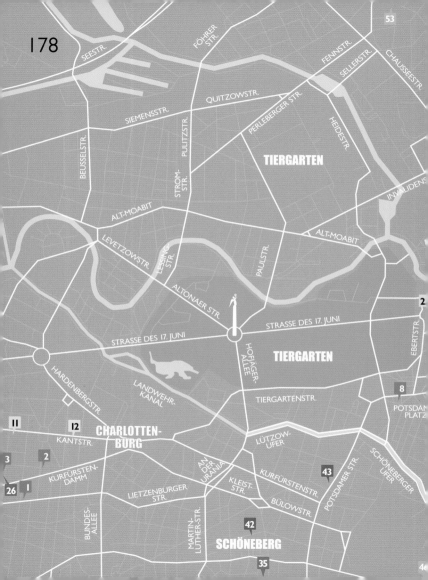

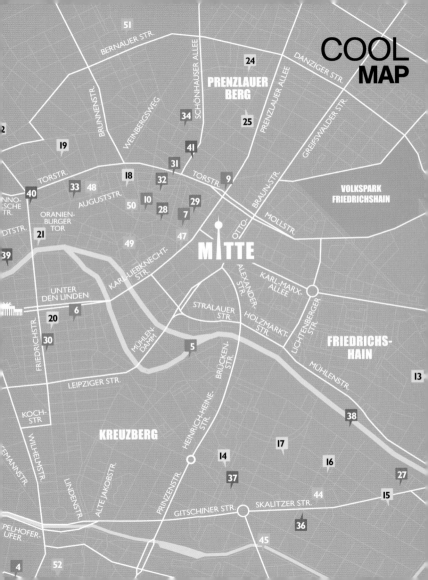

EMERGENCY

Ambulance/Fire Tel.: 112
Police Tel.: 110

ARRIVAL

BY PLANE
Information on airports and security
regulations: Tel.: +49 (0)1 80 5 00 01 86
www.berlin-airport.de
website also in English

SCHÖNEFELD AIRPORT (SXF)
18 km/11 miles south of the city center.
National and international flights.
Free shuttle service or 5–10 min. walk
from terminal to station. For city center,
take S9, Regionalbahn or Airport Express
to Friedrichstraße or Zoologischer
Garten (30–45 min.).

TEGEL AIRPORT (TXL)
8 km/5 miles north-west of the city
center. National and international flights.
Take bus no. 128 from terminal to
Kurt-Schumacher-Platz subway station.
Take U6 to Friedrichstraße (30 min.),
bus no. 109/express bus X9 to
Zoologischer Garten
(via U7 Jakob-Kaiser-Platz,
20–30 min.) or TXL Express Bus

to Alexanderplatz (via Hauptbahnhof
and Friedrichstraße, 35 min.).

BY TRAIN
BERLINER HAUPTBAHNHOF
Europaplatz 1
www.hbf-berlin.de
Berlin's new Central Station
is located close to the city center
and the Reichstag. Direct connection
to local lines S3, S5, S7, S75.
Tel.: +49 (0)800 1 50 70 90
(automatic timetable information),
Tel.: +49 (0)118 61 (travel service).
www.bahn.de – Official multilingual
website of Deutsche Bahn

TOURIST INFORMATION

BERLIN
TOURISMUS MARKETING (BTM)
Am Karlsbad 11
10785 Berlin
Tel.: +49 (0)30 25 00 25
Fax: +49 (0)30 25 00 24 24

information@btm.de
(to order information material)
reservierung@btm.de
(ticket and hotel reservations,
vacation packages), phone service

Mon–Fri 8 am to 7 pm and
Sat–Sun 9 am to 6 pm
Berlin info stores are located at:
Hauptbahnhof, Level 0, northern entrance,
Brandenburg Gate, Alexanderplatz,
Neues Kranzler Eck, Kurfürstendamm 21,
Berlin Pavillon am Reichstag, Scheide-
mannstraße and Europa Center, Budapester
Straße 45. Further information points
can be found at the airports.
www.berlin.de – Berlin's official website
offering multilingual information and
services
www.visitberlin.de
Hotels, tickets, and special tips by
Berlin Tourismus Marketing, great
multilingual website
www.berliner-stadtplan.com
City maps

ACCOMMODATION

www.berlinzimmer.de
Hotels, bed & breakfast, rooms etc.,
website also in English
www.berliner-hotelzimmer.de
Hotels and bed & breakfast

TICKETS

www.hekticket.de – Wide range of tickets
for concerts, cabaret, theater, and other
events in Berlin, website also in English

Berlin WelcomeCard
Free trips on all public transportation in
the specified VBB region (fare regions
A, B, and C) as well as a 50% discount
on tickets for over 120 different tourist
attractions and cultural venues for adults
and up to three children under 15.
Available online, at cash machines,
Berlin info stores, hotels, public transport
ticket machines. A ticket for 48 hours
costs 16 euros, for 72 hours 22 euros.

GETTING AROUND

PUBLIC TRANSPORTATION
www.bvg.de
Official website of Berlin Public Transport,
also in English
Tel.: +49 (0)30 1 94 49
www.s-bahn-berlin.de
Official website of Deutsche Bahn
subsidiary S-Bahn, also in English
Tel.: +49 (0)30 29 74 33 33

TAXI
Tel.: +49 (0)30 26 10 26
Tel.: +49 (0)30 44 33 22
Tel.: +49 (0)8 00 2 22 22 55
Tel.: +49 (0)8 00 2 63 00 00

BICYCLE RENTALS

http://fahrradstation.de – Bike rental, bike services, and more
Tel.: +49 (0)1 80 5 10 80 00
http://stadtundrad.de/ – Rentals and Fat Tire Tours in English and Spanish, website also in English
Tel.: +49 (0)30 68 83 62 17
www.callabike-interaktiv.de
Registration Tel.: +49 (0)7 00 (0)5 22 55 22 (from 6.2 ct/min.) or register online
Rent is 7 ct/min. or max. 15 euros/day (24 hrs); bicycles are rented via cell phone, payment is by credit card or direct debit
www.bbbike.de – Bicycle route finder for Berlin, website also in English

CAR RENTAL

Beside the international rental car companies there are some Berlin based like:
www.robben-wientjes.de
Also small trucks and vans
www.allround.de – All kinds of vehicles
www.esautovermietung.de
Budget car rental
www.lex.de
All kinds of vehicles, also for heavy loads
www.autos-weine.de
Unusual combination: cars and wines

CITY TOURS

BUSES AND TRAMWAYS

Taking the bus or tram is the cheapest way of touring the city. Bus no. 100 and bus no. 200, which run between Bahnhof Zoo and Alexanderplatz, pass some of the main attractions. A tramway ride on line M1 takes you from Bahnhof Friedrichstraße to Prenzlauer Berg, passing Hackesche Höfe and Kastanienallee.

SIGHTSEEING BUSES

www.berolina-berlin.com
Berolina Sightseeing
Tel: +49 (0)30 88 56 80 30
www.bbsberlin.de
Berliner-Bären-Stadtrundfahrt
Tel: +49 (0)30 35 19 52 70
www.severin-kuehn-berlin.de
Severin & Kühn
Tel.: + 49 (0)30 8 80 41 90

BOAT TOURS

www.sternundkreis.de
Stern- und Kreisschifffahrt
Tel.: +49 (0)30 53 63 60-0
www.reedereiwinkler.de
Reederei Winkler
Tel.: +49 (0)30 34 99 59 33

COOL
CITY INFO

GUIDED TOURS

www.artberlin-online.de — Art:berlin,
Tel.: +49 (0)30 28 09 63 90
In organized themed tours, you get to know
Berlin's cultural, artistic, and urban landscapes
http://stattreisenberlin.de/berlin
Stattreisen Berlin, Tel.: +49 (0)30 4 55 30 28
Walks around the city with
a focus on history, society, and politics
www.stadtverfuehrung.de
Stadtverführung
Tel.: +49 (0)30 4 44 09 36
Tours on historical or contemporary themes

TRABI "SAFARI"

www.trabisafari.de
Event & Touring AG
Tel.: +49 (0)34 92 26 65 07
+49 (0)177 2 75 47 59

SIGHTSEEING FLIGHTS

www.air-service-berlin.de
Air Service Berlin CFH GmbH
Tel.: +49 (0)30 53 21 53 21
Commander Frank Ticket-Hotline

VIEWING THE CITY FROM ABOVE

www.tv-turm.de
www.sehenswuerdigkeiten-berlin.de/
berliner-funkturm.html
www.panoramapunkt.de

ART & CULTURE

www.art-in-berlin.de
Current and permanent
exhibitions and museums
www.stadtentwicklung.berlin.de/denkmal
Information on the most significant
monuments in Berlin, also in English
www.berliner-galerien.de
Professional representation of
art galleries in Berlin, also in English
http://blog.tixclub.de
Online magazine, specials, and free tickets
www.eyeout.com/berlin
Mobile art guide app for iPhone

GOING OUT

www.berlin030.de
Parties, music, cinema, and more
www.berlinatnight.de
Things happening at night,
and hotels and tickets
www.clubcommission.de
Club info

www.berlin.de
Berlin's official website
offering multilingual
information and services
www.berlin-programm.de
Well-arranged event calendar

COOL
CITY INFO

www.zitty.de
Online city magazine
www.tip-berlin.de
Online city magazine

EVENTS

FASHION
www.fashion-week-berlin.de – also in English
www.mercedes-benzfashionweek.com
also in English
www.breadandbutter.com
multilingual website

ART & DESIGN
www.lange-nacht-der-museen.de
The long night of the museums
www.berlinbiennale.de
Festival of international
contemporary art, also in English
www.gallery-weekend-berlin.de
Taking place during the Biennale
www.transmediale.de
International festival for contemporary
art and digital culture, also in English
http://dmy-berlin.com – International
Design Festival, also in English
www.art-forum-berlin.de
International fair and exhibition of
contemporary art, also in English

MUSIC
www.berlin-music-week.de
Huge music platform including
Berlin Festival, Popkomm and many
other events, workshops, and panels.
Website also in English
www.berlinfestival.de
Berlin's biggest Electronic and
Indie Festival, also in English
www.popkomm.de
International music business fair,
also in English
www.karneval-berlin.de
Big procession with floats, music, and
lots of dancing, starting in Neukölln
and going through Kreuzberg,
accompanied by many open air events
with live music, website also in English

FILM
www.berlinale.de
International Film Festival Berlin,
bilingual website

COOL
CREDITS

COVER by mkrberlin-Fotolia
Illustrations by Lizzy Courage

p 2–3 (Spreebogen) by Jörg Tietje
p 6–7 (Berlin) by Thomas Lottermoser/
www.manganite.net
p 8–9 (Hotel Concorde) by Martin Nicholas Kunz
(further credited as mnk)

HOTELS

p 12 (Bleibtreu Berlin) left top and bottom by
Thomas Schweigert, right by Kessler + Kessler,
Zürich; p 14–16 (Q!) p 15 left top and right top by
Gavin Jackson, all other photos by Dirk Schaper/
courtesy of Loock–Hotels; p 18 (SETs) all photos
by Achim Kleuker; p 20–22 (Riehmers Hofgarten) all
photos by mnk; p 24 (art'otel) all photos courtesy
of art'otel; p 26–28 (Hotel de Rome) all photos
courtesy of The Rocco Forte Collective; p 30–33
(Lux11) all photos by diephotodesigner.de; p 34–36
(The Mandala) all photos by Andreas Tauber/
courtesy of Madison; p 38–40 (Soho House Berlin)
p 38, 39, 40 left bottom and right by Chris Tubbs,
all photos courtesy of Soho House; p 42–44 (The
Weinmeister) p 42 by Henrik Pfeifer, p 43, 44 left
top and right by Tom Tomczyk, p 44 left bottom by
diephotodesigner.de

RESTAURANTS + CAFÉS

p 50 (Jules Verne) all photos by David Burghardt
(further credited as db); p 52 (Paris Bar) all photos by
E. A. Baur/courtesy of Paris Bar; p 54–56 (Schnee-
weiss) all photos by mnk; p 58 (Babanbè) all photos
by db; p 60 (Chez Gino) all photos by db; p 62–64
(Der Goldene Hahn) all photos by db; p 66–68
(3 Schwestern) p 66–67 by Tim Klöcker/103prozent.
de, p 68 all photos by db; p 70 (Al Contadino Sotto
le Stelle) all photos by db; p 72 (Alpenstueck) all
photos courtesy of Alpenstueck; p 74–76 (Borchardt)
all photos by Jörg Tietje; p 78–80 (Grill Royal) p 78 by
Lepkowski Studios Berlin, p 79–80 photos by Stefan
Korte; p 82 (La Bonne Franquette) all photos by db;

p 84–86 (Uma Restaurant) all photos courtesy of
Uma Restaurant; p 88 (Anna Blume) all photos by
Eisenhart Keimeyer; p 90 (Pasternak) all photos by db

SHOPS

p 94 (BCBGMaxazria) all photos by db; p 96 (Over-
kill) all photos courtesy of Overkill; p 98–100 (Acne)
all photos by db; p 102 (Blush Dessous) all photos by
Markus Bachmann; p 104 (Cabinet 206) all photos
by Frank Hülsbömer; p 106–109 (Kaviar Gauche)
all photos courtesy of Prag PR; p 110 (lala Berlin) all
photos by db; p 112 (Wunderkind Vintage) all pho-
tos by Beate Wätzel; p 114 (lucid21) all photos by
Markus Bachmann; p 116 (Kochhaus) all photos by db

CLUBS, LOUNGES + BARS

p 120–122 (Soju Bar) all photos by Felix Park; p 124
(Würgeengel) all photos by db; p 126–128 (Spind-
ler & Klatt) all photos by diephotodesigner.de;
p 130 (Bar Tausend) photo courtesy of Bar Tausend;
p 132 (King Size) all photos by Stefan Korte; p
134–136 (White Trash Fast Food) all photos by
db; p 138–140 (Green Door) all photos by diephoto-
designer.de; p 142–144 (Victoria Bar) Kerstin Ehmer
& Katja Hiendlmayer

HIGHLIGHTS

p 150 (Edsor Kronen) left and right bottom by db,
right top by Gregor Hohenberg; p 152–154 (Markt am
Maybachufer) all photos by mnk; p 156 (Viktoriapark)
all photos by db; p 158–160 (Buchstabenmuseum)
all photos by db; p 162 (Clärchens Ballhaus) left
bottom by Bernd Schönberger, other photos by db;
p 164–166 (Hackescher Markt) all photos by mnk;
p 168 (Spirit Yoga Mitte) all photos by mnk; p 170
(Mauerpark) right top by mnk, all other photos
by db; p 172 (Tempelhof) top and right bottom
by courtesy of Berliner Immobilienmanagement BIM,
left bottom by Günter Wicker/Berliner Flughäfen;
p 174 (Stattbad Wedding) left top by Just/just.eko-
system.org, other by db; p 190 (Kreuzberg) by db

A NEW GENERATION
of multimedia lifestyle travel guides
featuring the hippest most fashionable
hotels, shops, and dining spots for
cosmopolitan travelers.

VISUAL
Discover the city with tons
of brilliant photos and videos.

APP FEATURES
Search by categories, districts, or geo locator;
get directions or create your own tour.

ISBN 978-3-8327-9484-2

BRUSSELS
VENICE
BANGKOK
MALLORCA+IBIZA
NEW YORK
AMSTERDAM
MIAMI
MEXICO CITY
HAMBURG
LONDON
ROME
MILAN
BERLIN
FRANKFURT
STOCKHOLM
BARCELONA
COPENHAGEN
LOS ANGELES
SHANGHAI
TOKYO
SINGAPORE
VIENNA
BEJING
COLOGNE
PARIS
HONG KONG
MUNICH

A NEW GENERATION

of multimedia travel guides featuring
the ultimate selection of architectural
icons, galleries, museums, stylish
hotels, and shops for cultural and
art conscious travelers.

VISUAL

Immerse yourself into inspiring
locations with photos and videos.

APP FEATURES

Search by categories, districts, or
geo locator, get directions or create
your own tour.

ISBN 978-3-8327-9435-4

COPENHAGEN
SHANGHAI
TOKYO
SINGAPORE
BEIJING
VIENNA
PARIS
SYDNEY
HONG KONG
MUNICH
ZURICH
NEW YORK
SAO PAULO
AMSTERDAM
MIAMI
MEXICO CITY
HAMBURG
LONDON
ROME
EMIRATES
CHICAGO
MILAN
BERLIN

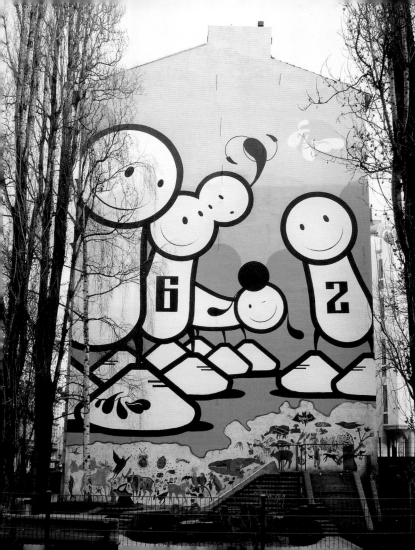

© 2011 Idea & concept by Martin Nicholas Kunz, Lizzy Courage Berlin
Selected, edited and produced by Aishah El Muntasser;
Martin Nicholas Kunz, Lizzy Courage Berlin, www.lizzycourage.de
Texts by Aishah El Muntasser
Editorial coordination: Sina Milde
Photo Editor: David Burghardt
Copy editing: Inga Wortmann, Dr. Simone Bischoff
Art direction: Lizzy Courage Berlin
Imaging and pre-press: Jan Hausberg
Translations: Übersetzungsbüro RR Communications Romina Russo,
Heather Bock, Robert Rosenbaum (English), Sylvia Lyschik, Romina Russo (Spanish),
Samantha Michaux, Élodie Gallois (French)

© 2011 teNeues Verlag GmbH + Co. KG, Kempen

teNeues Verlag GmbH + Co. KG
Am Selder 37, 47906 Kempen // Germany
Phone: +49 (0)2152 916-0, Fax: +49 (0)2152 916-111
e-mail: books@teneues.de

Press department: Andrea Rehn
Phone: +49 (0)2152 916-202 // e-mail: arehn@teneues.de

teNeues Digital Media GmbH
Kohlfurter Straße 41–43, 10999 Berlin // Germany
Phone: +49 (0)30 700 77 65-0

teNeues Publishing Company
7 West 18th Street, New York, NY 10011 // USA
Phone: +1 212 627 9090, Fax: +1 212 627 9511

teNeues Publishing UK Ltd.
21 Marlowe Court, Lymer Avenue, London SE19 1LP // UK
Phone: +44 (0)20 8670 7522, Fax: +44 (0)20 8670 7523

teNeues France S.A.R.L.
39, rue des Billets, 18250 Henrichemont // France
Phone: +33 (0)2 4826 9348, Fax: +33 (0)1 7072 3482

www.teneues.com

Bibliographic information published by the Deutsche Nationalbibliothek.
The Deutsche Nationalbibliothek lists this publication in the
Deutsche Nationalbibliografie; detailed bibliographic data are
available in the Internet at http://dnb.d-nb.de.

Printed in the Czech Republic
ISBN: 978-3-8327-9486-6